Greenwood

In the first decades of the 20th century, Greenwood was one of the most prosperous and progressive towns in Mississippi. Local photographers and national companies recorded images of businesses, churches, homes, and civic buildings to place on postcards, an increasingly popular means of sending a quick note to friends and family. This generic floral background was probably used for dozens of towns throughout America. Most of the postcards reproduced in this book are unique to Greenwood. (Courtesy of Donny Whitehead.)

ON THE FRONT COVER: In a common scene in early Greenwood, dozens of cotton–laden steamboats are lined up from Pelucia Bayou to Fulton Street. (Courtesy of Donny Whitehead.)

ON THE BACK COVER: The back cover shows Howard Street in the early 1900s. (Courtesy of Donny Whitehead.)

POSTCARD HISTORY SERIES

Greenwood

Donny Whitehead and Mary Carol Miller

ARCADIA
PUBLISHING

*To all those who have been a part of Greenwood's history
and those who strive to preserve it for future generations*

CONTENTS

ACKNOWLEDGMENTS

Throughout its long history, Greenwood has been blessed with people who recognized the importance of documenting and preserving that history. Many have passed on, but we are fortunate to have access to the memories and wisdom of Allan Hammons, Imogene Lewis, Sara Criss, Mary Charlotte Clarke, Frances House, Seth Wheatley, Marion Howard, Jack Ditto, Noll Davis, Warner Wells Jr., and Horace Kitchell, among others too numerous to mention. The staff and volunteers of Cottonlandia Museum have put in long hours to collect and display our local story, and the Greenwood Leflore Library staff oversees an extensive newspaper and genealogy collection. The Viking Range Corporation and Staplcotn have invested heavily in the revitalization of downtown Greenwood, and Greenwood Main Street oversees its promotion. Without people willing to invest time and talent in Greenwood's past, it would disappear in a generation, and we are grateful to each and every one of these friends.

Thanks also go to Katie Shayda of Arcadia Publishing for her expert advice and unflagging patience. Katie and her cohorts at Arcadia are doing a marvelous job of preserving America's visual record, and we appreciate their willingness to include Greenwood in their catalog.

Unless otherwise noted, all images appear courtesy of Donny Whitehead. These postcards and many more images may be viewed at www.aboutgreenwoodms.com and www.baseball.aboutgreenwoodms.com.

INTRODUCTION

On November 15, 1834, the U.S. Government Land Office issued a certificate to John Williams entitling him to purchase 162.29 acres of land in Carroll County, Mississippi. At $1.25 per acre, his bill totaled $202.86. Williams signed his name, gathered up his deed, and passed possession of this swampy backwater acreage on to John McClellan just a few days later. Both men were likely speculators who had no intention of ever settling in this dangerous and untamed corner of the Mississippi Delta, but at least Williams left his name for posterity. According to the *Leflore County Deed Book*, Williams Landing included "Lots 8, 9, and 10 in Section 10 of Township 19North, Range 1East," or roughly the blocks that now lie between the Yazoo River, Walthall Street, Carrollton Avenue, and Avenue A. During the next decade, the little settlement on the Yazoo would attract more and more merchants and farmers with cotton to ship downstream, and in 1844, it was officially incorporated as Greenwood. The name honored Choctaw chief Greenwood Leflore, the largest landowner in the area and founder of Point Leflore, a short-lived and frequently flooded community at the juncture of the Tallahatchie, Yalobusha, and Yazoo Rivers.

Six months after incorporation, the new mayor, J. T. Reedy, and aldermen purchased land from Samuel B. Marsh and Titus Howard with the intention of laying out a true town, one that would stretch beyond the ramshackle collection of saloons, cotton sheds, and stores that lined the riverbank. As with most young towns in Mississippi, it was platted in a logical grid pattern, with the Yazoo as a natural northern boundary. A series of east–west streets ran parallel to Front Street, carrying the still familiar names of Market, Washington, and Church Streets. Intersecting them at right angles were Walthall, Main, Howard, and Fulton Streets. Considering that less than 150 souls called Greenwood home, it was an ambitious plan.

Life in pre–Civil War Greenwood was anything but elegant. Muddy banks led up from the Yazoo to dirt streets lined with saloons and small stores. Oxen pulled cotton wagons through town, stirring up clouds of dust in summer and mounds of muck in winter. An 1852 newcomer remarked that he was offered whiskey as soon as he stepped off the steamboat (at 8:00 a.m.!) and that almost every store of every sort offered liquor as a primary staple. That sort of liquid courage undoubtedly helped bolster the spirits of Deltonians of the day, who dealt with mosquitoes, snakes, alligators, panthers, and bears on a regular basis. Major floods inundated cropland and town alike in 1842, 1849, and 1850. Levees were scarce and untended, and most people had enough sense to build their homes in the hills east of town rather than risk malaria and snakebite in the lowlands of the Delta.

In spite of the physical hardships, Greenwood grew and prospered. By 1860, steamboats loaded with produce, building supplies, furniture, and anything else that locals could not produce for themselves were chugging upriver from Vicksburg. On their return south, their decks were stacked high with cotton, which had already become the staple that would fuel Greenwood's economic engine for the next century. Hotels opened to handle the steamboat visitors, and

gradually lawyers, doctors, bankers, and merchants filtered in to make their mark in the little town. The Civil War passed largely unnoticed, except for a significant skirmish at Fort Pemberton that temporarily halted U. S. Grant's progress toward Vicksburg.

After the chaos and economic stagnation of Reconstruction, Greenwood was perfectly situated to capitalize on the Industrial Age's insatiable demand for cotton fiber. Completion of levees in the 1880s opened up thousands of acres of unbelievably rich Delta land for cultivation, and the arrival of the railroads provided an alternative to the slow and cumbersome riverboat traffic. By the turn of the century, the "Second Cotton Kingdom" was in full swing, and Greenwood was Mississippi's premier boomtown.

Postcards created from 1900 to 1930 showcase a community that could afford one of the state's largest courthouses, fine churches, a castle-like primary school, and blocks of elegant homes. Tiny general stores were replaced by emporiums such as Fountain's Big Busy Store and J. Kantor's, "Outfitter to Mankind." The old riverfront hotels gave way to the 85-room Hotel Irving, which would figure so prominently in Greenwood's downtown revitalization as the Alluvian almost a century later.

The Greenwood scenes of these postcards and photographs reflect a town that managed to survive isolation, war, disease, and economic downturns to emerge as the Delta's premier city. Many show businesses, homes, and churches that have long since vanished, victims of shortsighted urban renewal and the need for more modern but less charming buildings. Others, though, show the earlier days of beloved structures that have endured for decades, somehow dodging the wrecking balls and thoughtless demolition that doomed so many of the city's finest architectural treasures. Greenwood experienced hard times after the heyday shown in these pictures, and those slow years saw many of downtown's best buildings shuttered and sagging. Increased awareness of historic preservation and the tourist potential in this old river town led to a rebirth of the downtown district in the late 1990s, anchored by the Alluvian Hotel and Viking Range's transformation of the old Cotton Row district into their corporate headquarters. The revitalization and restoration of Greenwood continues, and these historic photographs serve as reminders of what has been lost and what has been saved for future generations.

One

LIFE ON THE YAZOO

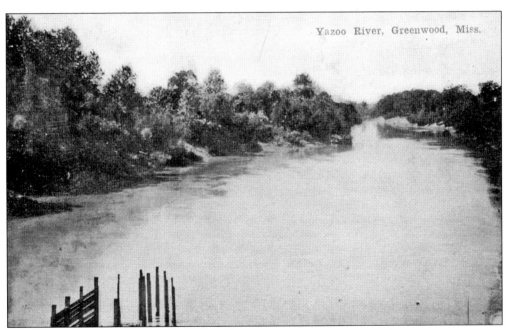

Yazoo River, Greenwood, Miss.

The Yazoo River begins at Point Leflore, where the Tallahatchie and Yalobusha Rivers converge just northeast of Greenwood. In 1834, John Williams paid $202.86 for 169 acres on the south bank of the Yazoo, an ideal site for shipping the cotton crop that was already dominating agriculture in the Mississippi Delta and nearby hill country. The tiny settlement was originally called Williams Landing, even though Williams owned the land for only nine days and died less than a year after his arrival. At the time of its incorporation in February 1844, the town had become Greenwood, in homage to the Choctaw chief whose lands encompassed much of the acreage between the new town and its nearest neighbor, Carrollton. Twenty-seven years later, the creation of Leflore County would complete the memorialization of Greenwood Leflore.

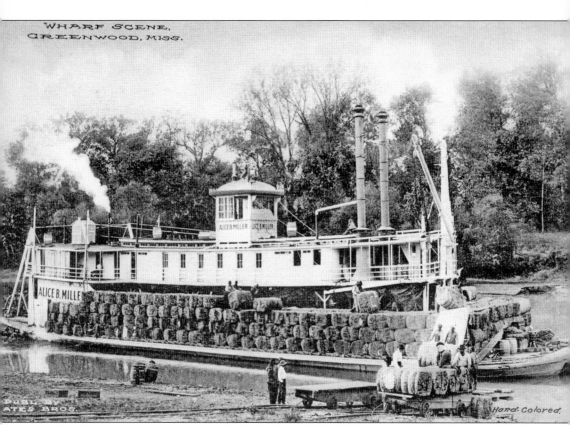

Steamboats had plied the Mississippi River since 1811, but they did not venture into the upper reaches of the Yazoo system until several decades later. In the antebellum era, the delta area surrounding Greenwood was largely unprotected by levees and was notorious for floods, disease, and mosquitoes. As a result, it was sparsely populated, and even those brave enough to establish farming operations in the lowlands generally built their homes and kept their families in the hills edging the Delta. The town of Greenwood was known as a convenient spot for planters to ship their cotton downstream, and a few stores and more than a few saloons opened to meet their needs. An 1852 newcomer recalled that he was offered a drink as soon as he debarked from the steamer *Mammoth Cave* and that this was "the customary greeting in those days." Over the next 70 years, hundreds of steamboats such as the one pictured here would arrive in Greenwood, carrying supplies for the area's residents and departing loaded down to the waterline with cotton bales.

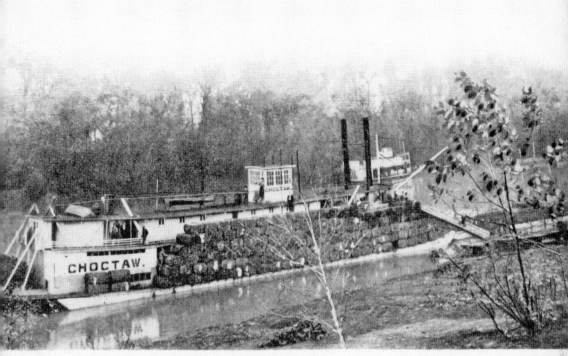

'86 Cotton on Yazoo River Steamer, Greenwood, Miss.

While this postcard depicts an early-1900s steamboat, the design remained similar to those that first ventured upriver to Greenwood from Vicksburg or wove their way through the Yazoo Pass into Moon Lake, down the Coldwater River, into the Tallahatchie, and eventually to the Yazoo. Sidewheelers gradually gave way to more-efficient stern-wheelers, and they arrived loaded down with produce, building supplies, furniture, and other essentials. Multiple wharves sprang up between the mouth of Pelucia Bayou and the end of Fulton Street, and on any given day in the late 1800s, there might be 30 or more boats of all shapes and sizes tied up along the south riverbank. Ox-drawn wagons laden with cotton bales churned their way through muddy streets to off-load the valuable white produce of the Delta.

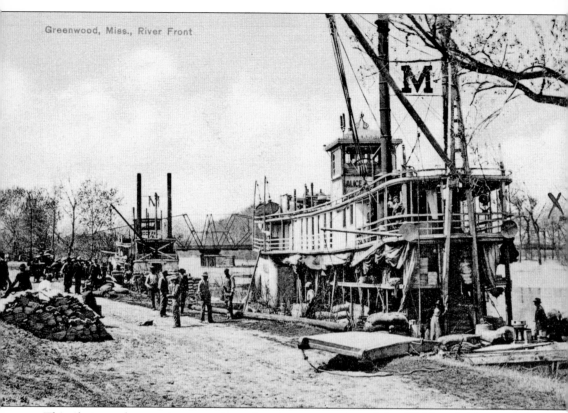

Greenwood, Miss., River Front

This photograph was taken sometime after the construction of the 1899 iron bridge over the Yazoo (visible in the background) and before it was demolished to make way for the Keesler Bridge in 1925. Both bridges were designed to rotate on a central pier, an unusual but necessary feature since river traffic continued to be quite active well into the 20th century. This scene is probably at the foot of Main Street, with Front Street evident in the center of the picture. The Yazoo appears to be just a few feet below the street level, and what seems to be a pile of sandbags to the left side of the street may indicate concern about rising water. November to March was prime season for cotton boats; during the slower summer months, showboats were a more common sight.

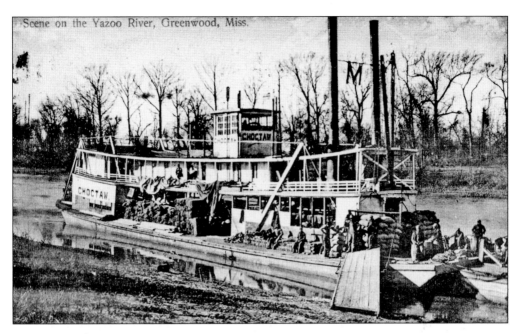

Scene on the Yazoo River, Greenwood, Miss.

Even after the arrival of the railroads in the Mississippi Delta, steamboat travel and transport held on. Between 1870 and 1880, the number of named riverboat landings on the Yazoo soared from 250 to 400, though many were little more than plantation wharves. Yazoo City and Greenwood were the only towns of any notable size on the waterway, and many of the larger boats ran under the "Mystic P" logo of Yazoo City's Parisot Lines. The largest were *Yazoo Valley* (which burst its boilers and sank just above Greenwood, one of dozens of sunken ships that littered the Yazoo over the decades), *City of Yazoo*, *Cherokee*, and *S. H. Parisot*. A frequent sight at the Greenwood wharves was the stern-wheeler *Choctaw*, owned by Gideon Montjoy.

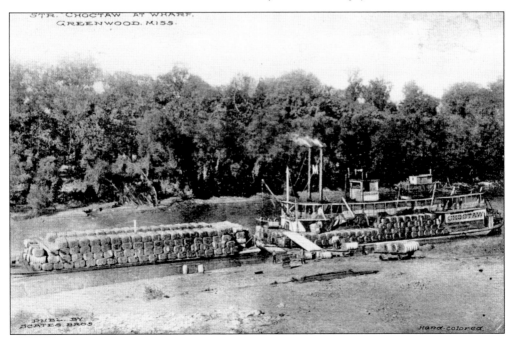

STR. CHOCTAW AT WHARF. GREENWOOD, MISS.

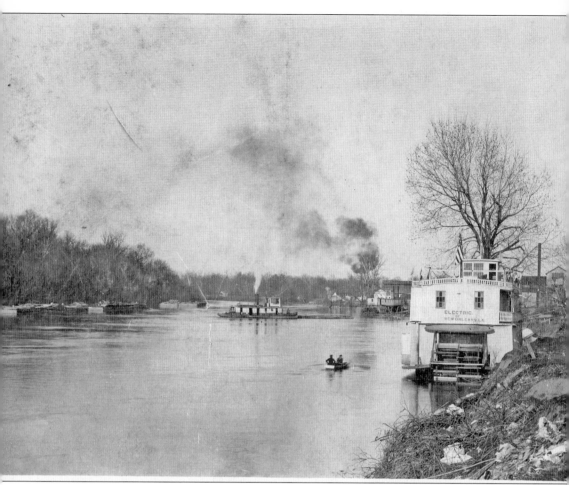

The railroads would eventually make river traffic obsolete. In 1887, more than 13,000 bales of cotton were shipped downriver from the Greenwood docks, but freight trains hauled more than 30,000 that same year. By 1900, river cartage had shrunk to just 2,000 bales, and the river that had given birth to Greenwood was receding as a viable economic element. A few steamboats and showboats, including the *Electric* (shown), continued to chug through the Delta until the 1930s. Jacob Weiss's sawmill is visible in the right-hand background of the picture, which was probably taken from the north end of Fulton Street in the late 1890s or early 1900s. Notice the two well-dressed men in a small boat and the thick woods on the north bank of the river. (Courtesy of Imogene Lewis.)

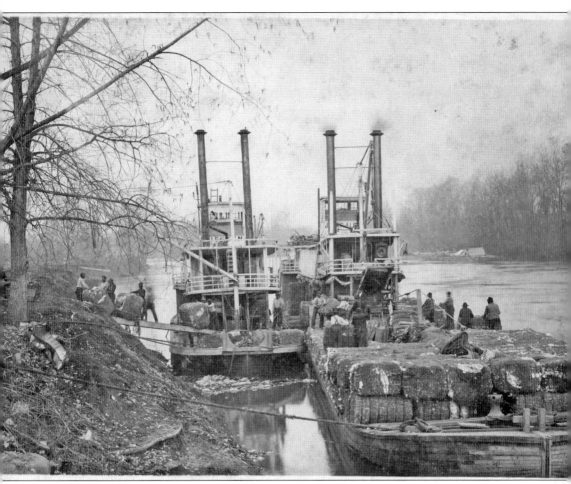

This riverboat scene predates 1899, when the original iron bridge over the Yazoo was built; no such structure is visible in this photograph. The most likely location is at the foot of Main or Walthall Streets. Loading the huge cotton bales onto the boats was dangerous, backbreaking work. Many men were required to wrestle the 300- to 400-pound bales down a ramp and onto the deck of the boat. It appears that the two large stern-wheelers pictured here are lashed together, and the bales are being eased down a narrow ramp onto the first deck and then flipped onto the second ship. The cotton will make its way to Vicksburg and New Orleans and eventually around the world to mills and factories. (Courtesy of Imogene Lewis.)

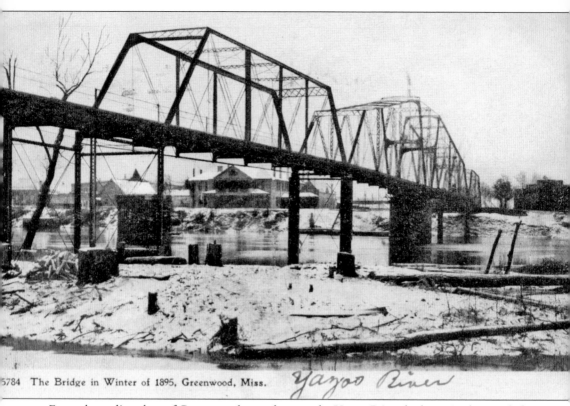

5784 The Bridge in Winter of 1895, Greenwood, Miss. *Yazoo River*

From the earliest days of Greenwood, travel across the Yazoo River had required a rough ferry ride from the base of Cotton Street to the north bank of the stream. Howell's Ferry was still the only means of traversing the river for the 200 inhabitants of North Greenwood in the 1890s. Responding to increasing support for a more permanent solution by constituents on both sides of the river, Leflore County supervisors' president Staige Marye threatened to build his own toll bridge if voters didn't pass a bond issue for the project. The 1899 measure squeaked through, and Marye quickly hired Groton Bridge Company to design and construct the span. At a cost of $25,000, the work was completed in a matter of months, putting an end to the choppy ferry rides. In this photograph, the date of 1895 is an error, as the bridge was not built until four years later. Note the Reiman Hotel to the left of the bridge and the building that likely was the first Leflore County Courthouse on the right side.

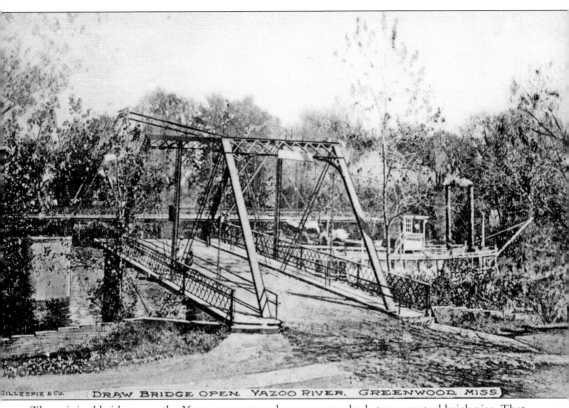

DRAW BRIDGE OPEN. YAZOO RIVER. GREENWOOD, MISS.

The original bridge over the Yazoo was a two-lane span perched atop a central brick pier. That pier would later be incorporated into the Keesler Bridge's supports. At the time of the bridge's 1899 construction, river traffic necessitated a means of clearing the channel for steamboats to reach the upriver wharves and access the Tallahatchie and Yalobusha Rivers. In a rare design, the bridge was able to pivot 90 degrees on its central pier, allowing the tall stacks to pass. The county supervisors quickly found out that rules had to be laid down for the new structure: bicycles were banned and no one was allowed to drive or ride "faster than a walk." This photograph's depiction of the narrow lanes, low railings, and frighteningly high waters suggest that it wasn't hard to enforce such a law. To the right, a wooden structure juts away from the central pier toward the upstream side, intended to divert debris away from the bridge's primary support.

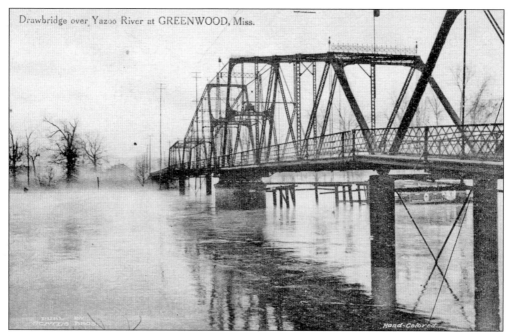

Drawbridge over Yazoo River at GREENWOOD, Miss.

Within 25 years of its construction, the 1899 iron bridge was obsolete. Its completion had enabled local businessmen to develop and market the Boulevard Subdivision in North Greenwood, and that community was incorporated in 1906. With Greenwood's population more than doubling (from 3,000 to 7,000) in the first seven years of the new century and the arrival of more and more automobiles, it was obvious that a wider, more modern bridge would be needed. In 1924, a flimsy temporary wooden bridge was thrown across the Yazoo at the old Howell's Ferry site, and the iron bridge was pulled down, leaving only the massive central pier. The lower photograph was likely made from the tower of the 1906 Leflore County Courthouse looking towards North Greenwood. Notice the Ford Model T and numerous pedestrians crossing the bridge.

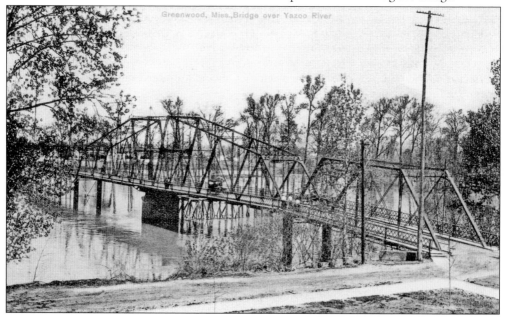

Greenwood, Miss., Bridge over Yazoo River

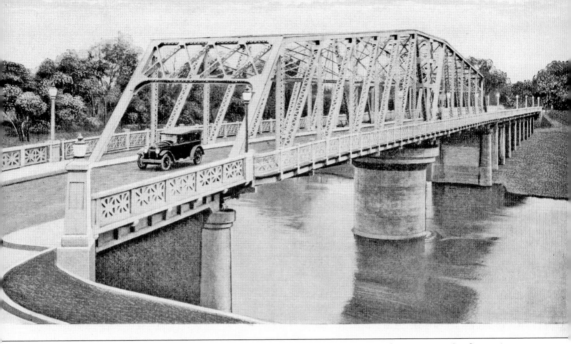

Bridge over Yazoo River, Greenwood, Miss.—5

The Keesler Bridge was built by Riley-Bailey Construction Company of St. Louis. The first caisson was sunk into the Yazoo's waters in October 1924, and Mrs. S. R. Riley steered a Dodge coupe across the span just six months later. The $187,000, 290-foot moveable swing-through Howe truss structure had been finished in record time, reflecting the increasingly vital connections between Greenwood and North Greenwood. On April 12, 1925, Fannie Weaver threw a switch to illuminate the electric lamps, and the bridge was officially opened to the public. Greenwood Leflore's great-great-granddaughter, Elizabeth Leflore Ray, christened the steel with a bottle of Malmaison spring water. Local newspapers claimed that 10,000 people lined the riverbanks for the ceremony. Like its predecessor, the Keesler Bridge pivoted on its central pier. Though river traffic had slowed to a trickle, city leaders felt they should keep their options and the shipping lanes open in case of a resurgence.

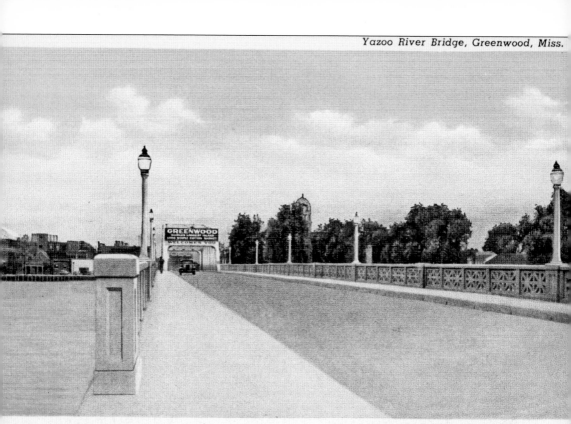

9A484

Completion of the Keesler Bridge firmly cemented the merger of Greenwood and North Greenwood into one large community. Businesses began to develop along with suburban homes north of the Yazoo, and Highways 49 and 82 were routed across the bridge, down Grand Boulevard, and out Park Avenue. The Keesler turned on its giant pier for the last time in 1952, when dozens of local dignitaries were trapped for some time as the ancient gears froze in place. The machinery was eventually stripped out and discarded. The lamps were also removed, but many were salvaged by private citizens and later returned to the bridge. Without proper maintenance, the old span was becoming increasingly dangerous, and it was almost demolished in the late 1990s. Citizens with a sense of history rallied and convinced civic officials to undertake a multi-million dollar restoration instead, preserving this historic and unique bridge for future generations.

Two

DOWNTOWN DEVELOPS

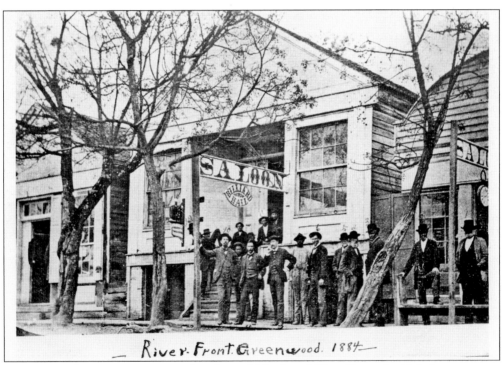

Six months after its 1844 incorporation, Samuel Marsh and Titus Howard sold their property to the Town of Greenwood, whose mayor and aldermen laid out a system of streets on a grid pattern. Marsh's name was lost to time, perhaps because no one in this swampy frontier would want a house on Marsh Street. Titus Howard, on the other hand, was memorialized in the name of the community's primary business thoroughfare. Front Street, River Road, Main Street, Market Street, Church Street, and Washington Street were all to be seen on the earliest maps. For the first decades of its existence, most of Greenwood's business community remained clustered along Front Street, the first two blocks of Howard and Main Streets, and Market Street. Houses lined the neighboring blocks that would eventually become the city's commercial core.

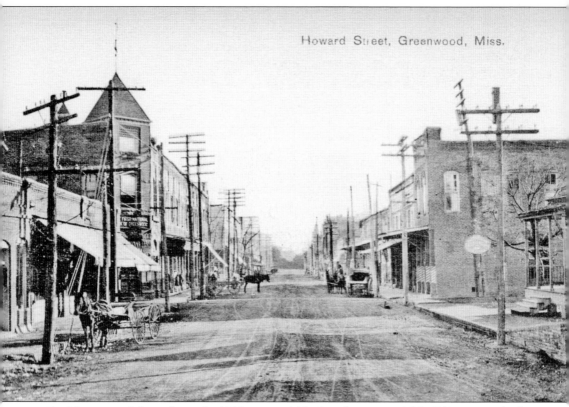

Howard Street, Greenwood, Miss.

In this postcard from the early 1900s, several blocks of commercial buildings stretch along Howard Street south from the Yazoo riverfront. All were relatively new; 1890 and 1893 fires destroyed most of the 19th-century structures in Greenwood. Note the towered First National Bank on the left; Henderson and Baird Hardware's original building is just to the south of the bank. Across Howard Street, the small building with a porch in the foreground is a telegraph office. Next to is a barbershop with multiple striped pilasters advertising the business. Telephone poles line the street along the sidewalks, an arrangement which did not survive the arrival of automobiles. The steeple of the Church of the Nativity can be seen in the distance on the right, dating this photograph to 1902 or later.

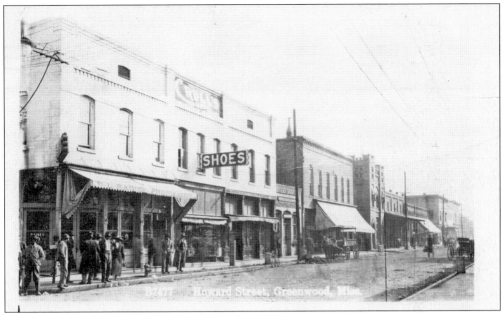

These are two shots looking south down Howard Street from the intersection with Market Street. The top shows Crull's Shoe Store and, on the corner, Raines Pharmacy. The building with the large awning on the left was occupied by Weiler's Jewelry Palace and Musical Forest, which Albert Weiler claimed as "the finest and most complete stock of diamonds, watches, fine jewelry, cut glass, silver novelties, ornaments and bric-a-brac ever shown in the South." The second floor of this building would be destroyed by fire on Christmas Eve, 1934. The awning further down the street marks Fountain's store, located in the same building that housed Barrett Drugs for many years. In the 300 block of Howard Street, the three two-story commercial buildings that still exist are in place. The bottom photograph clearly shows a picket fence and houses in the distance on the right where Fountain's store would be built in 1914.

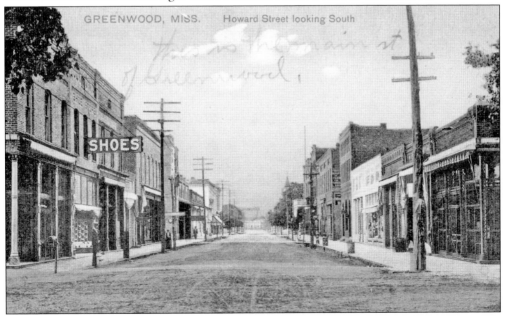

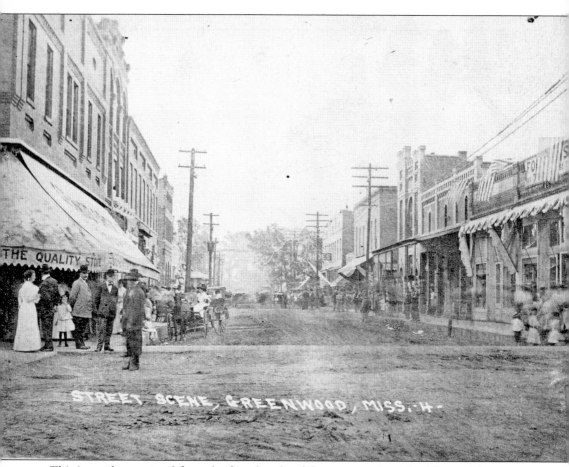

THE QUALITY STO...

STREET SCENE, GREENWOOD, MISS. 14

This is another postcard from the first decade of the century, depicting Howard Street as seen from its intersection with East Washington Street. Both sides of the 200 block of Howard are easily recognizable to today's citizens, although the buildings' occupants have changed. The three-story building on the left corner features an awning advertising "The Quality Store;" after housing several businesses over the years, it was destroyed in a 1980s fire. Just north of it is the building that has been renovated for the Blue Parrot Café, Veronica's Bakery, and a blues museum. Beyond it is brickwork that has been covered by an aluminum facade for decades, and across the street is the familiar castle-like facade of Fincher's Antiques, originally a bank building. In the right foreground is the old Fountain's location, with its awnings rolled up. This structure would also eventually be lost to fire.

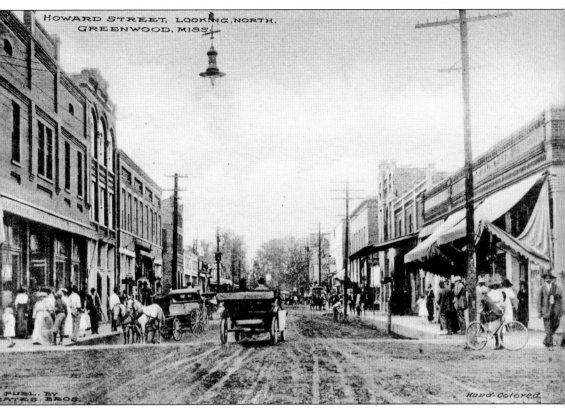

This is a later depiction of the same Howard and Washington intersection. More cars are evident, but the street is still unpaved and horses far outnumber the automobiles. Fountain's name remains on the one-story building on the right, indicating that the date is pre-1914. Greenwood Furniture has moved into the large building in the left foreground. Telephone poles are between the sidewalk and the street, their wires likely strung from the telephone exchange at the far end of the block. The two-story building that housed the Delta Bank is visible on the left, halfway up the block, but the Wilson Bank at Howard and Market Streets has not yet been constructed. Large trees are seen at the north end of the street, presumably on the Yazoo levee. The object seemingly suspended in mid-air at the top center of the photograph is probably a carbon arc streetlamp.

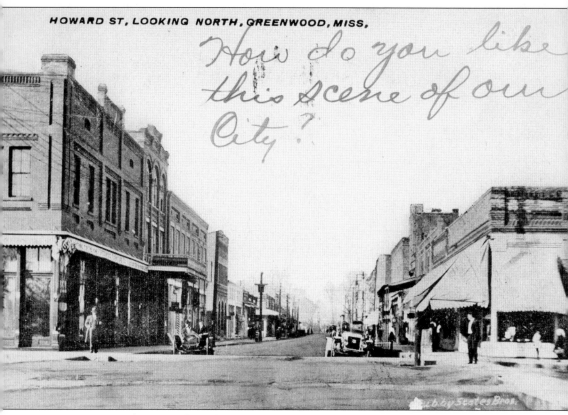

How do you like this scene of our City?

Here is yet another scene from the same viewpoint as pages 22 and 23. The horses and carriages are gone, and the streets appear to be paved. Several cars are lined up at the curbs, although the vehicle in the right foreground has either parked at an odd angle, tipped into a pothole, or suffered a flat tire. A covered porch has been added to 222 Howard Street, and the elaborate brickwork of its neighbor to the north, long covered by an aluminum facade, is visible. With the arrival of more cars, the city's telephone poles have been moved from the street to less conspicuous locations.

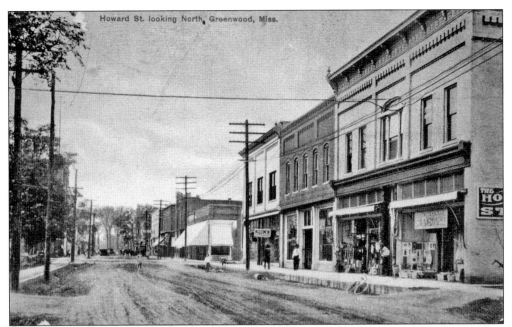

The postcard photographer has moved half a block south from the previous three photographs, standing approximately in front of the present-day Giardina's Restaurant. There is no sign of the three-story Fountain's building, which would come to dominate the 300 block of Howard Street, so this photograph is from around 1912. The three connected storefronts on the right side of the street are brand new but would be instantly recognizable almost a century later. Note, as in previous pictures, the rows of telephone poles running right down the side of the thoroughfare and the dirt streets. Also note the bicycle casually propped against the curb in front of the brown brick store, a sure sign that there were not enough cars around to endanger someone's prized bike.

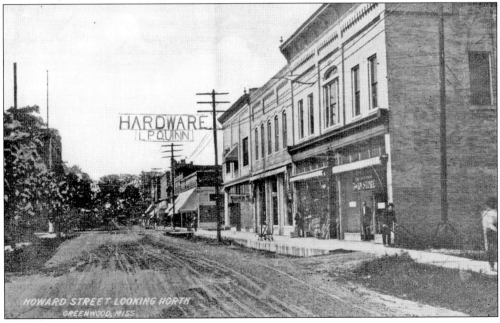

27

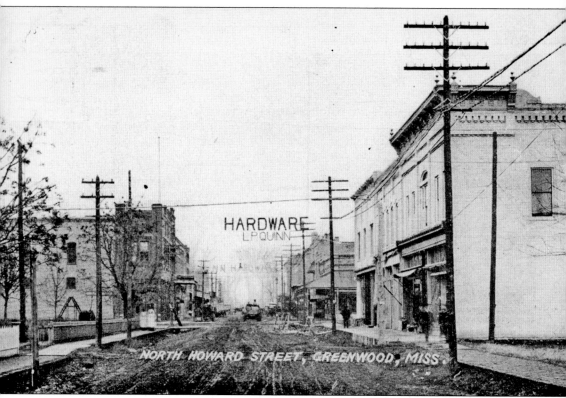

HARDWARE
L.P.QUINN

NORTH HOWARD STREET, GREENWOOD, MISS.

This scene, shot from the same location and angle as those on page 27, shows stark evidence of Greenwood's abysmal streets in the early 1900s. The sidewalks are crude, and the step-offs into the street are eroded and muddy. The picket fence on the lot where Fountain's would soon be built is seen once again. There is a tree visible on the right-hand side of the photograph in foreground, indicating that work on the building that would house J. Kantor's Men's Store (built around 1917) had not yet begun.

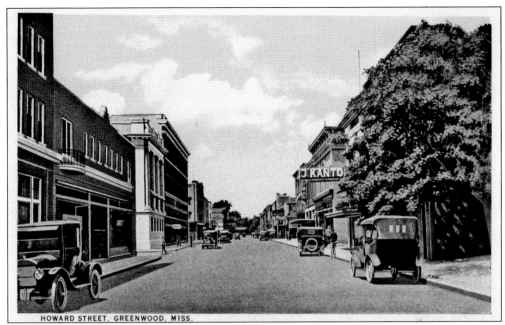

HOWARD STREET, GREENWOOD, MISS.

The appearance of J. Kantor's and the Irving Hotel (left front) dates these pictures as post-1917. The street itself is paved and curbed, and Fountain's Big Busy Store now dominates the west side of the block. W. T. Fountain had completed the $40,000, three-story, 22,500-square-foot building in just a few months of 1914. Its grand opening attracted shoppers and sightseers who were rewarded with "dainty souvenirs" and the music of the Big Six Orchestra. Most took their first ride on an elevator that day and marveled at the ladies and menswear departments, the "snug corset try-on nook," toys, home furnishings, glass, and chinaware. J. Kantor's opened three years later, replacing one of several houses on that half-block that were torn down for commercial development. Ten-year-old Adeline Kantor laid the first brick for her father's building, which would be renamed the Adeline after her death a few years later.

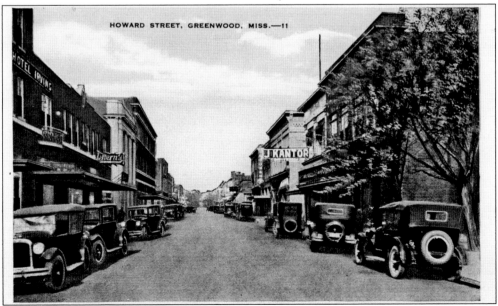

HOWARD STREET, GREENWOOD, MISS.—11

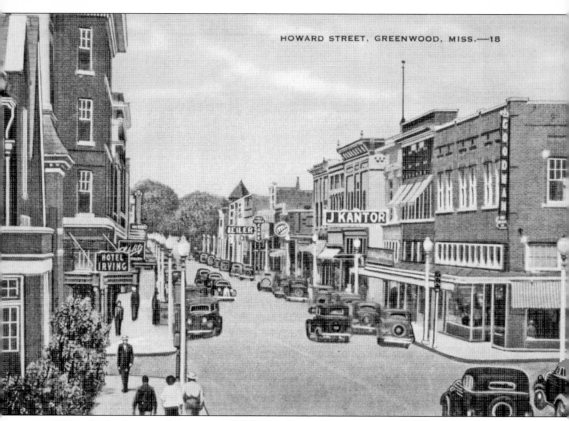

This colorized postcard from the 1930s looks almost like a drawing, but the people strolling along in the forefront indicate a live shot. Goodman's occupies the corner building that would one day house J.C. Penney's and later the Viking Cooking School, Alluvian Spa, and Mockingbird Bakery. The 1923 Bright Building houses Woolworth's, and J. Kantor's is just to its north. On the same side of the street, Weiler's Jewelry's sign is visible, as is the enduring McBee Building. The iconic Post Office Café sign, which would hang in front of the Hotel Irving for many years, is seen just south of Weiler's. The Church of the Nativity is in the left foreground, and both sides of Howard Street are lined with attractive globed lampposts.

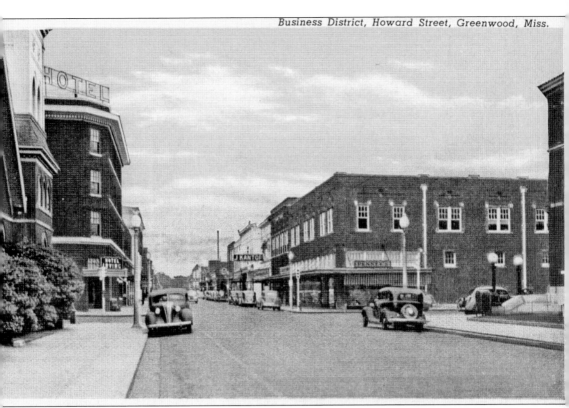

This idealized view looking north on Howard Street from the mid–400 block appears to be from the 1930s. The Church of the Nativity has mature shrubbery, and the Irving Hotel dominates the left side of the street, complete with the huge "Hotel" sign that remained on the roof long after that hostelry had ceased to function. The corner of the 1914 U.S. Post Office is visible on the right, including the globe lanterns which are still there almost a century later. J.C. Penney's has replaced Goodman's Dry Goods on the northeast corner of the intersection. Note that the stoplight is located on the sidewalk rather than hanging over the intersection. In the distance is a tall shaft of unknown purpose, which seems to be mounted on the Barrett's Drug Store building.

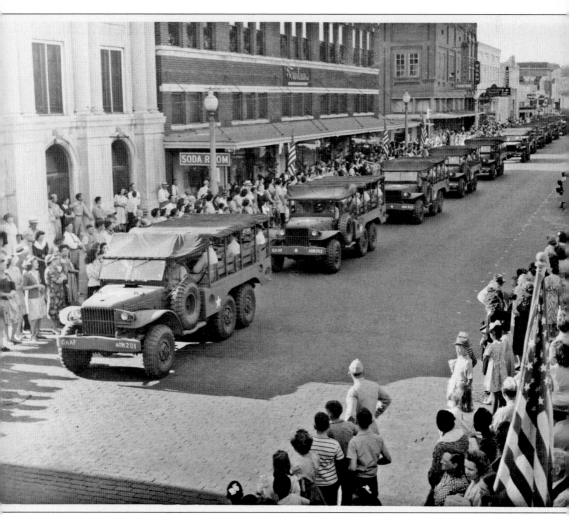

This World War II army parade down Howard Street illustrates Greenwood's main business thoroughfare at the peak of its prosperity. On the left, the Bank of Commerce has taken over the old First National Bank location, and Fountain's has added a soda fountain. With the streets jammed for the parade, many observers are watching from the second floor (and, presumably, the third floor) windows of the department store. Further down the street, Jordan's Furniture has moved into the Greenwood Furniture building, next door to WGRM radio. Beyond those buildings are a paint store, Mamelli's Optical Shop, and the 1919 Wilson Bank, where the 1930 Greenwood bank crisis began. It later housed the Bank of Greenwood, Leflore Bank and Trust Company, Deposit Guaranty, and Planters' Bank.

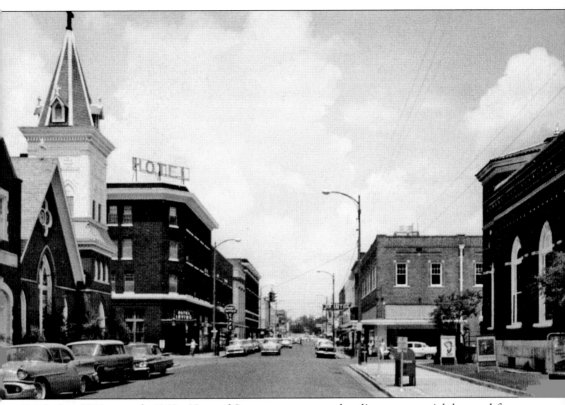

By the late 1950s or early 1960s, Howard Street was a mature, bustling commercial thoroughfare. The Irving Hotel was still the primary place to stay downtown overnight; its accompanying restaurant, the Post Office Café, was a prime spot for diners and coffee drinkers. Stein's Jewelry and DeLoach's completed that half-block of Howard Street. Across the street, Kantor's clothed men, Woolworth's boasted the best candy counter in the Delta, and J.C. Penney's offered clothing, shoes, fabric, and housewares. Fountain's closed in the late 1950s, and its building would see several smaller tenants before a long period of total vacancy. The Hotel Irving declined in the 1970s as well, its inhabitants dwindling to just a few long-term renters before it closed altogether in the latter part of the decade. By 2000, DeLoach's, Kantor's, Woolworth's, and J.C. Penney's had all disappeared from Howard Street.

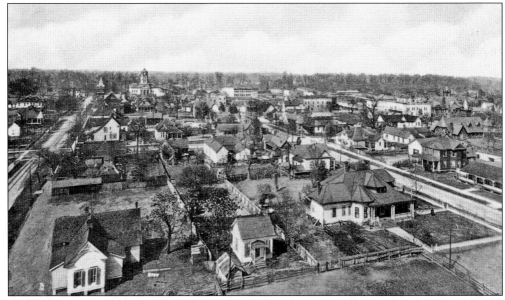

Aerial views offer a fascinating glimpse of Greenwood as it developed through the 20th century. The photographer for these shots was probably perched on top of the Greenwood Utilities plant or its water tower, looking north toward the Yazoo River. In the top photograph, Cotton Street runs along the left side and Fulton Street along the right. The presence of the Leflore County Courthouse (1906) dates the shot to post-1906; the absence of the Hotel Irving and Fountain's indicate that it was taken no later than 1913. Notable is the fact that almost all of downtown is residential rather than commercial. The Charles Wright house, Daisie, is prominent in the lower edge of both photographs. The Church of the Nativity and the First Presbyterian Church are clearly visible; both were built before 1905. In the bottom photograph, the U.S. Post Office (1914), Fountain's store (1914), and the Hotel Irving (1917) are all standing, as is the steeple of the original First Methodist Church just behind Fountain's.

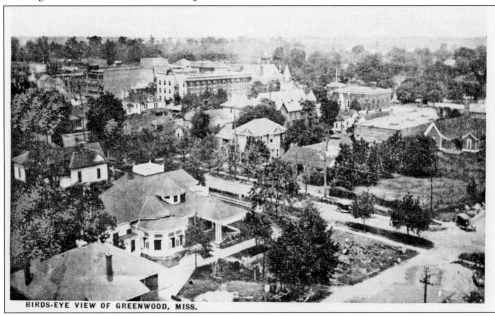

BIRDS-EYE VIEW OF GREENWOOD, MISS.

34

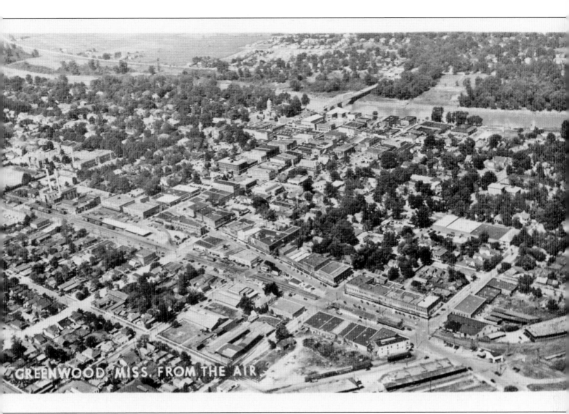

GREENWOOD, MISS. FROM THE AIR

This aerial photograph shows a vibrant downtown Greenwood, with buildings so tightly packed together that they are somewhat difficult to differentiate. The 1952 wings of the courthouse are not in place yet. The south end of Grand Boulevard already has large oaks lining it, and the empty fields north of West Claiborne Avenue presage the hundreds of homes that will be built there in the post–World War II era. On the left edge of the photograph, halfway up, is the complex of Davis School buildings and Greenwood High School. In the lower right corner are the Illinois Central Depot, the Crystal Grill, and a complex of lumber warehouses that burned in the 1970s. Just east of the Keesler Bridge is the Greenwood Leflore Hotel, the successor to the long-standing Reiman Hotel. The Greenwood Leflore was demolished in the 1960s for a bank building. Two blocks to the east of the hotel, near the point where the Veterans Memorial Bridge would be built in the 1960s, the sports arena behind Myrick Ford (Viking Culinary Center) is still visible.

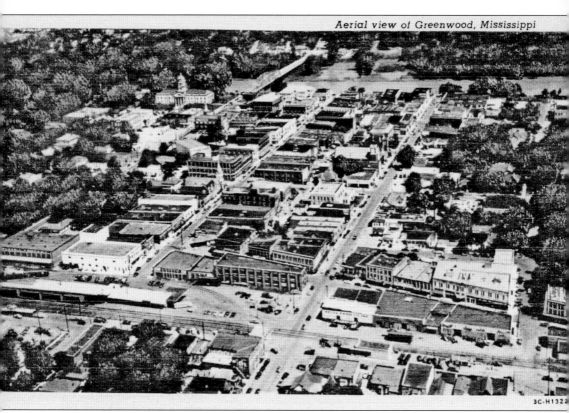

This shot from an airplane, likely in the mid-1950s, shows a downtown Greenwood that has reached maturity. The Leflore County Courthouse has been enlarged twice and achieved its final appearance. Just beyond the courthouse, the 1925 Keesler Bridge leads to North Greenwood, where development is obvious through the thick tree foliage. Almost all of the Victorian-era homes along Fulton, Howard, and Main Streets have given way to commercial and civic development. In the lower right corner, the Midway Hotel occupies half of the Carrollton Avenue block between Walthall and Main Streets. The odd triangular shape of Quinn Drug Company is seen one block west, and the 1930 art deco city hall has replaced the Bryan house on the southwest corner of Main and Cotton Streets. To its immediate west, the U.S. Post Office has been enlarged to its final size.

Three

Public Buildings

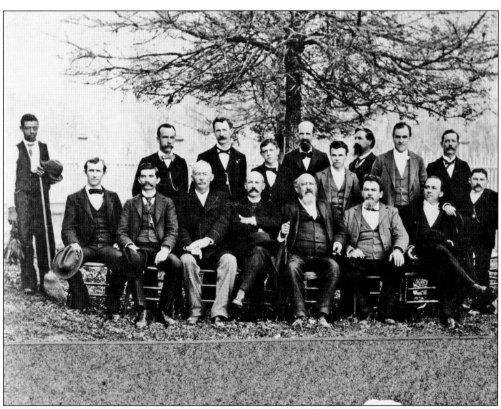

Fifty years after John Williams laid his claim on the south bank of the Yazoo, Greenwood was one of Mississippi's fastest growing and most prosperous cities. Between 1890 and 1930, the profit from all aspects of the cotton industry would allow the city and county to build some of the finest public buildings and municipal facilities in the state. An outdoor portrait of the Leflore County officials taken in 1896 includes two future governors: A. H. Longino (first row, arms crossed) and J. K. Vardaman (far right, legs crossed, first row).

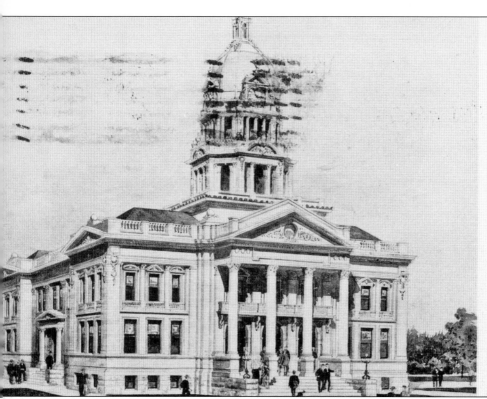

Court House,
Greenwood,
Miss.

1816

STONE FROM
NATIONAL STONE
COMPANY,
BLOOMINGTON,
INDIANA.

Greenwood developed in Carroll County, whose government seat was already claimed by Carrollton. When Leflore County was carved out of Sunflower, Carroll, and Grenada Counties, a new government center was necessary, and Greenwood was the obvious location. Because the town had already been developing for almost three decades, there was no "court square" proper as seen in many Mississippi towns. The first small courthouse had been built in the 1870s on the riverside lot traditionally associated with Choctaw justice and execution rituals, although no hard evidence has ever surfaced to support that claim. By 1904, as Greenwood was experiencing exponential population growth and an economic boom from its status as the cotton–marketing center of Mississippi, it was obvious that a larger, finer courthouse would be required. In August 1904, the board of supervisors advertised for bids between $75,000 and $100,000 to be submitted for a brand new courthouse. This architectural rendering captures the final plan for the new building, although many of the more elaborate details were never included.

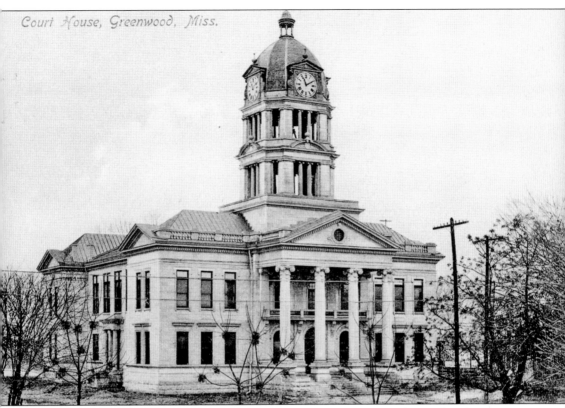

Court House, Greenwood, Miss.

Several buildings, including the original courthouse, were demolished to make way for Chattanooga architect R. H. Hunt's massive new government building. The Guyton Harrington livery stable and delivery service, on the northeast corner, was bought after hard negotiations between Gov. James K. Vardaman (a Greenwood resident) and Harrington. The Arnold home was moved to another location, and the Marye and Craig homes were torn down. An alley that bisected the block from east to west was eliminated, and construction of the monumental Alabama limestone structure began. Its sheer bulk and soaring three-stage clock tower were intended to reinforce Greenwood's preeminence as one of Mississippi's most prosperous cities. Jesty Construction Company of Winona broke ground in June 1905 and completed the work in just 15 months. Five thousand people jammed the grounds for a barbecue and political rally at the opening; the *Greenwood Commonwealth* noted that several of the gubernatorial candidates present were at each other's throats before the festivities ended. In this early photograph, the building barely visible on the left may be the 1870s courthouse.

39

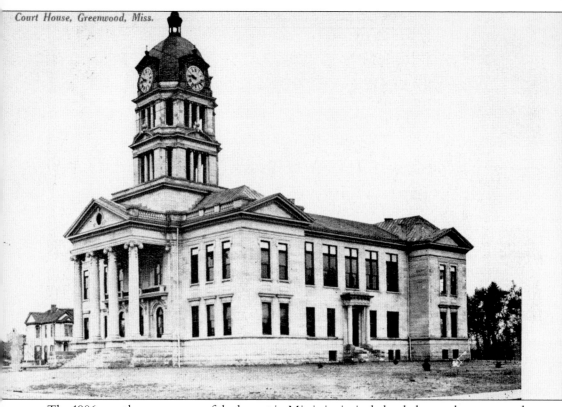

The 1906 courthouse was one of the largest in Mississippi, rivaled only by much more populous counties such as Hinds and Warren. The three-stage tower included four enormous clock faces that could be seen from almost anywhere in Greenwood. In 1934, Lizzie George Henderson donated a mechanism of Westminster chimes in memory of her husband, Dr. T. R. Henderson. Each quarter-hour added another line of the prayer: "Lord, through this hour / Be thou our guide / So by thy power / No foot shall slide." Generations of Greenwoodians have subconsciously estimated the time by the bells of Miss Lizzie's chimes.

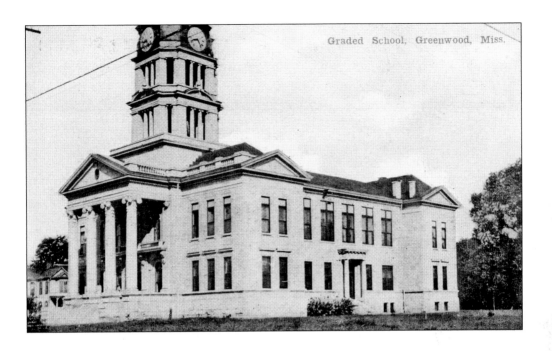

Postcards were often locally produced, but some were manufactured at distant sites by workers who had no idea what they were viewing. These two photographs of the Leflore County Courthouse were taken after its completion in 1906 but before the rear addition was built in 1927. The top photograph has it mislabeled as "Graded School, Greenwood Mississippi." The bottom photograph has a corrected caption, but it would be intriguing to know how many cards were produced before the mistake was noticed.

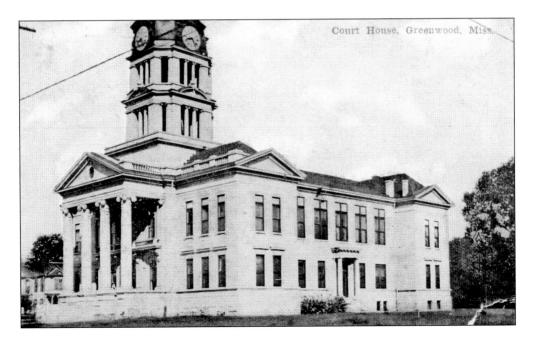

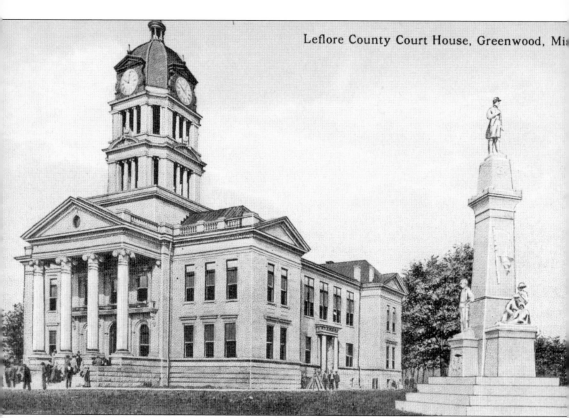

In 1913, just seven years after the completion of the new courthouse, a unique Confederate monument was erected on the southeast corner of the lawn. Greenwood was swept up with a wave of Lost Cause nostalgia, along with the rest of Mississippi and the South, as the veterans of the Confederacy began to dwindle rapidly in numbers. Almost every town in Mississippi commissioned a memorial, usually with a lone soldier and often delivered from Columbus Marble Works. A full century later, the economic status of a community in the early 1900s can be reasonably estimated by the size, detail, and location of its Confederate monument. Greenwood, flush with cotton money and political clout, wound up with the largest collection of statues outside of the Vicksburg National Military Park.

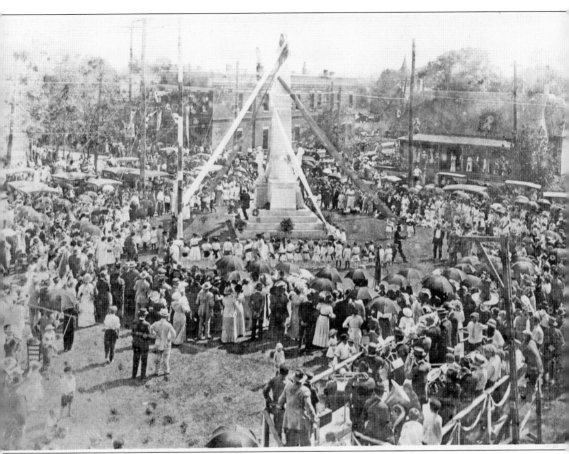

The driving force behind the elaborate Confederate Monument was the local chapter of the United Daughters of the Confederacy (U.D.C.), an active and financially powerful group of determined matrons. Not content with the usual "private on an obelisk" brand of memorial, these stalwarts contracted with Columbus Marble Works for no less than six carved figures to be arranged upon a multistage marble base. The pilot wheel of the ill-fated *Star of the West* was carved into one side of the pedestal, along with enough accumulated verbiage to fill a considerable book. Through the summer and early fall of 1913, workers labored under a heavy tarp, bolting the statues into place and putting the finishing touches on the crowded monument. On the morning of October 9, a living chain of veterans' grandchildren encircled the hidden structure and pulled the coverings away, revealing the figures to a vast crowd gathered on the lawn and perched on neighboring rooftops. As if that weren't enough of an event, 600 ancient Confederate veterans had hobbled into town to bask in one last moment of adulation.

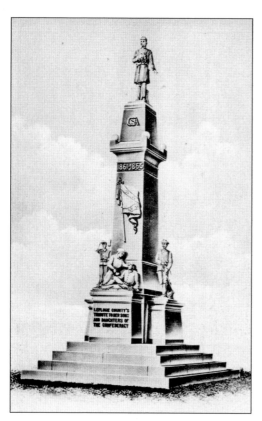

In all, a total of six figures were commissioned for the Greenwood Confederate Monument. The original contract called for "the best personally selected flawless silver gray Georgian marble" and "statuary [to] be cut out of the best perfect Italian marble, cut in Italy." The top statue was given in memory of Gen. B. G. Humphreys, later governor of Mississippi and a Leflore County landowner. The single woman (designated in the design specifications as a "sure enough woman") was modeled on Sallie Morgan Kimbrough Clements; the two figures on the opposite side were donated in memory of Lewis Sharkey Morgan, a 15-year-old enlistee killed at Collierville, Tennessee. His niece and great-nephew posed for the figures.

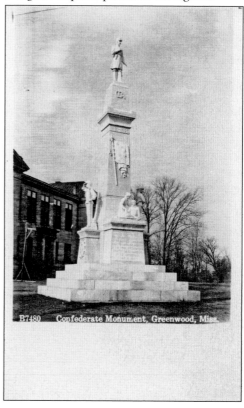

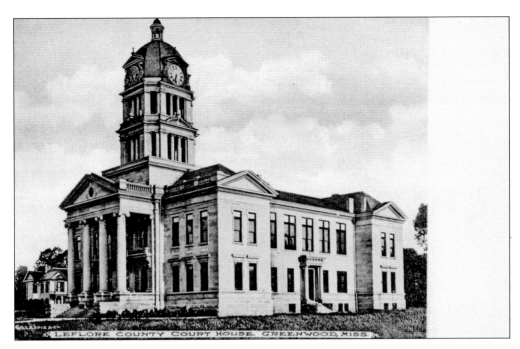

Massive as it was in 1906, the courthouse was bursting at the seams with county business and offices by 1927. In that year, Frank McGeoy designed and built a $125,000 annex on the north end of the structure. It blended perfectly with the neoclassic facade of the original building and provided much-needed office and jail space. Within two years of its completion, the entire indebtedness from both the 1906 and 1927 projects was paid off. The lower postcard shows mature trees flanking the east side of the building and the same sidewalk-mounted stoplights as are seen in the Howard Street photograph on page 31.

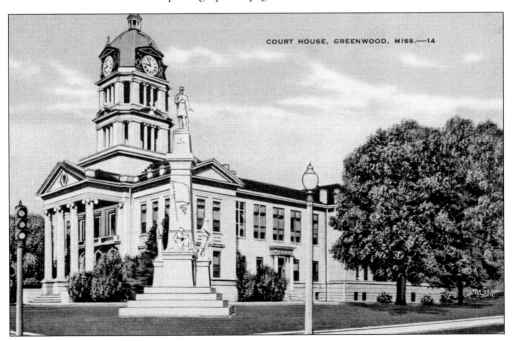

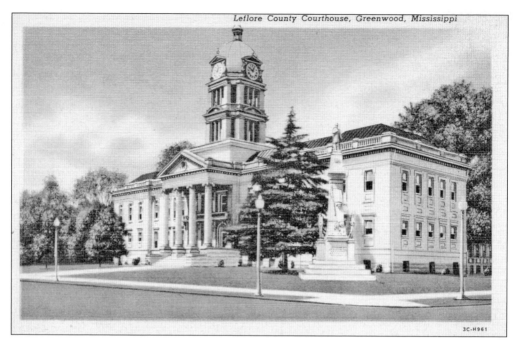

Leflore County Courthouse, Greenwood, Mississippi

In 1952, east and west wings were added to the original courthouse block, balancing the overall structure and leaving it in a graceful "T" shape. In the 1970s, engineers would discover that the seemingly impregnable banks of the Yazoo River were actually riddled with caves and washed-out strata, endangering the entire building's stability. County offices were packed up and moved down River Road to the long-abandoned hospital. Over the years, ill-conceived interior renovations have destroyed the original courtroom and many of the fine 1906 details, but there is still a wealth of architectural value in the century-old courthouse.

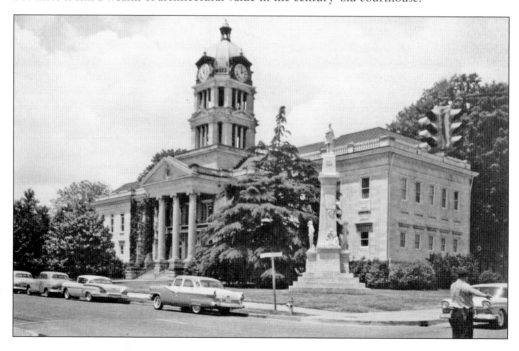

The dedication of the Confederate Monument on the courthouse lawn in 1913 wasn't the last effort of Greenwood's U.D.C. chapter to commemorate their Confederate ancestors. Richmond, Virginia, had recently opened a Confederate Memorial Building, and Lizzie George Henderson decided that Greenwood had to keep pace. She and her husband, Dr. T. R. Henderson, called a meeting at First Baptist Church to launch a fund-raising drive for a similar building. The U.D.C. and the Women's Club (whose memberships tended to mirror one another to a remarkable degree) ponied up $4,500, and their persistence coerced the Leflore County Supervisors to add $5,000 of taxpayer money. A local veterans' group threw in another $500, the Hendersons donated an empty lot, and Frank McGeoy set to work designing the redbrick facade. The nation's second (and last) Confederate Memorial Building was dedicated with typical fanfare on April 15, 1915, immediately adjacent to the new Carnegie Library.

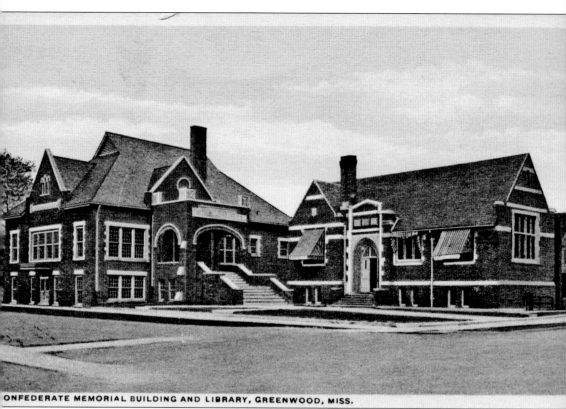

ONFEDERATE MEMORIAL BUILDING AND LIBRARY, GREENWOOD, MISS.

The Hendersons were also integral in the creation of Greenwood's first public library. They donated the large West Washington Street lot just behind their house for the site, and Lizzie George led the ubiquitous U.D.C. and Women's Club on a quest for Carnegie Foundation money. As always, they did not come back empty-handed; the foundation granted $10,000, the City of Greenwood added another $8,900, and Dr. Henderson wrote a check for $1,100 to round out the $20,000 tab. Those funds built a unique Jacobethan Revival brick structure with multiple steep-sided gables, tall chimney stacks, and stone-pointed arches. The shaped parapets and multi-paned windows completed the English effect. Dr. Henderson scoured the shelves of his late father-in-law's Carroll County mansion, Cotesworth, for suitable books to fill the shelves. He returned with almost a thousand volumes. During the Depression, local artist Lallah Walker Lewis was commissioned by the WPA to paint murals on the north and south walls of the library. This photograph shows the library before the 1954 north addition was completed.

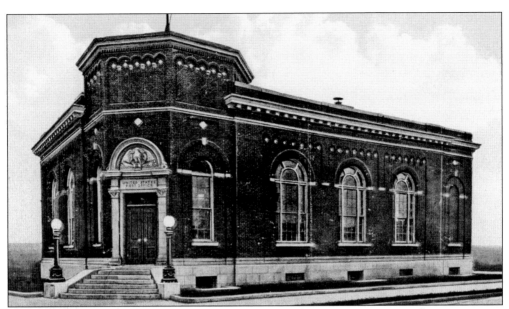

Greenwood's first true post office was built on the southeast corner of Market and Fulton Streets in the early 1900s; this building is visible behind the Confederate Monument on page 41. Later known as the Whittington Building, it housed postal workers in the front and a meat market in the rear. It would subsequently be converted to Magnolia Motor Company's Studebaker/Hupmobile dealership. In 1909, the federal government purchased the lot at the southeast corner of Howard and Church Streets, just north of the original First Baptist Church sanctuary. Two frame houses on the lot were demolished or removed that year, but work on the post office did not commence until 1911. The building, designed by architect James Knox Taylor, is a one-story brick structure with a polygonal bay corner entrance topped by a stern bas relief eagle. The original cast-iron lamp posts and sconces have survived the transition from post office to Greenwood City Schools Administration Building. The lower postcard shows the design in greater detail. Round-arched windows, a dentiled cornice, and a green tile roof marked this as one of the finest postal buildings in Mississippi.

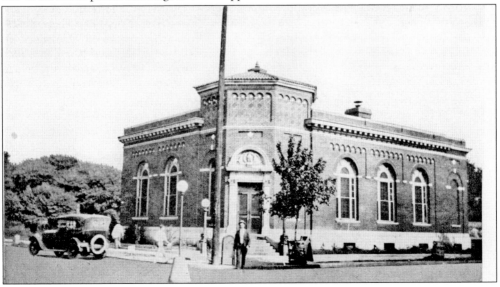

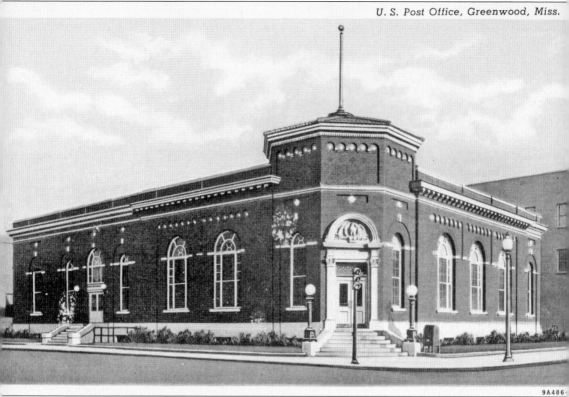

9A486

Less than 20 years after its dedication, the Greenwood Post Office was deemed inadequate. Congressman Will Whittington spearheaded appropriations bills to fund an enlargement of the building, and work began in 1927. Four bays were added to the east side of the structure closely matching the original brickwork and arched windows. This site would serve as the post office for another 40 years. In the late 1960s, an entire block of Greenwood's most elaborate Victorian-era houses was mowed down to make way for a bland federal building and post office complex. The old post office was converted to school administration offices, leading to the loss of the old brass mailboxes and a complete renovation of the interior. Fortunately, the exterior detailing of the building has remained intact.

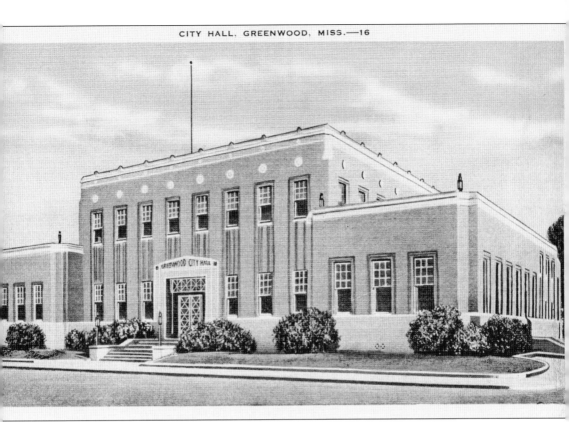

In 1904, city leaders revealed plans to build a new city hall on the site of the "old calaboose," as the county jail was known. The two-story square brick building served the city's government services on East Market Street for 26 years. In 1929, the Bryan House on the southwest corner of Church and Main Streets was moved and reassembled elsewhere as two homes for city employees. In its place, an elaborate art deco city hall went up housing all municipal departments, the police department, a small jail, and the fire department. Local architect R. J. Moor filled the yellow-brick facade with recessed panels and decorative stone medallions. Carved over the main entrance, the date 1930 belies the financial crisis that enveloped the nation during city hall's construction. Throughout numerous city administrations, the exterior of this building has remained remarkably intact, although many of the interior art deco touches have been eliminated.

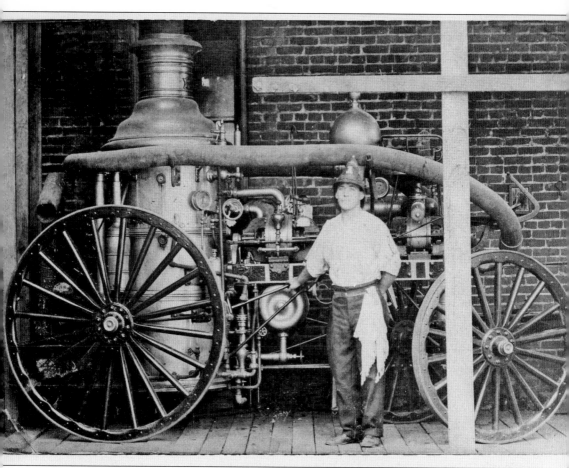

In April 1890, a windswept fire roared out of the Allen Hotel at the corner of Main and Front Streets, raging through downtown Greenwood and destroying almost every commercial structure and many homes. Fourteen years later, Mayor Will Vardaman took a $1,500 city check to Memphis's Seagrave Corporation and was handed the keys to a shiny new horse-drawn fire wagon. Three firemen made up the entire force that year, their combined salaries totaling $165 per month. Bids were let for a station and engine house to be built at the south end of Howard Street. While this was a vast improvement in fire protection for the city, not all went smoothly. One of the first alarms after the acquisition of the new wagon found the horses balking and refusing to pull the apparatus; the chief and assistants unhitched the stubborn horses, hooked up mules, and headed off to douse the blaze on South Fulton Street.

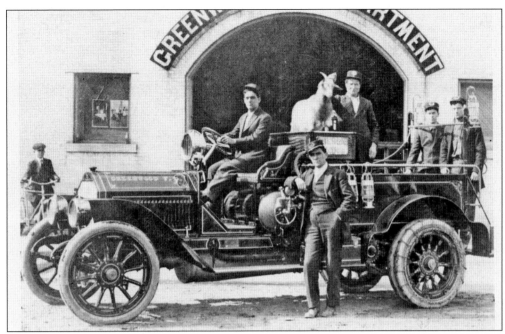

The arched doorway seen here have long since been filled in with woodwork, but the overall structure is readily recognizable as the old Fire Station No. 1. By the time this picture was made, after the transition to motorized fire engines, the force had apparently expanded to five men and a goat. This is probably the 1911 American LaFrance engine. Increased commercial and residential development along Carrollton Avenue led the city to build a second fire station near Avenue A, which was torn down in 1935 and replaced with the existing Fire Station No. 2. Station No. 1 was converted to a Red Cross headquarters in the 1940s and has been empty for several decades. A third fire station was included in the city hall complex of the early 1930s, and a North Greenwood station was built near the levee in the 1950s.

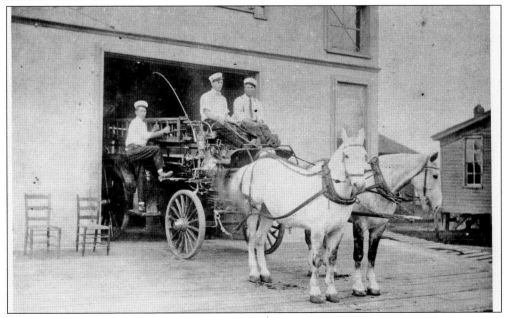

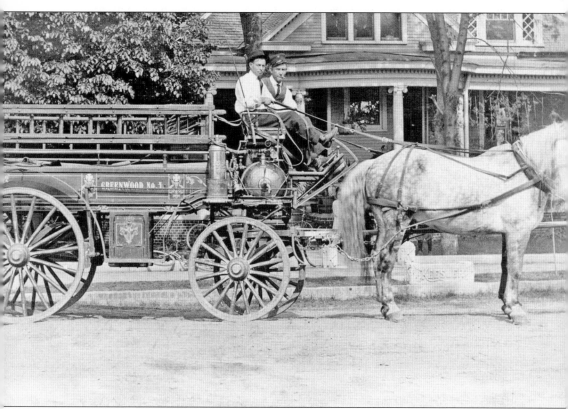

Greenwood's fire horses were as tough and durable as the firemen who drove the wagons. The horses were housed in a large stable behind Station No. 1 until the first motorized equipment was purchased in 1913. At that point, they were moved to the Carrollton Avenue station and retained for use when the roads were too icy or muddy for the trucks to run. In 1918, the fire department purchased a Ford Model T body from the E. K. Myrick dealership and had Jucheim Wagon Works convert it into a fire engine. Local lore relates that even after retirement, the two fire horses would bolt from their stable at the sound of the fire bells. In this photograph, notice the carriage block with "Keesler" carved into the front; the house in the background was built by Gen. Samuel Reeves Keesler and was known for years as the Telfair House. It stands on the southeast corner of Walthall and Church Streets.

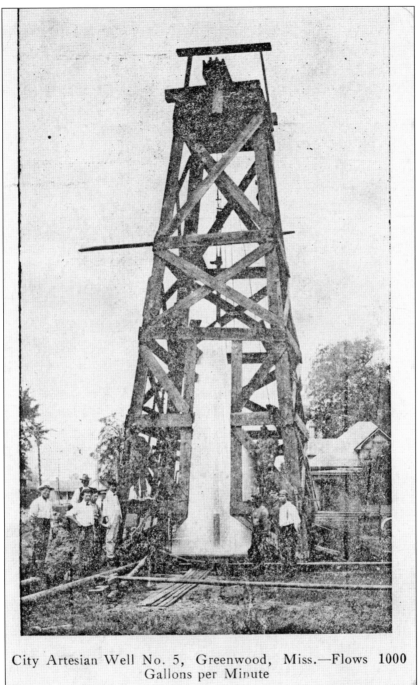

City Artesian Well No. 5, Greenwood, Miss.—Flows 1000
Gallons per Minute

Greenwood was justifiably proud of its firefighting efforts, but it was also boastful of its water. Charles Wright Sr. drilled the city's first artesian well in 1895, striking a spring at a depth of over 900 feet and forever changing the city's future. Wright built his own coal-powered electrical plant, which he sold to the city as the forerunner of Greenwood Utilities. He built a home for his wife, Daisie, in 1898, and it still stands as one of downtown Greenwood's few remaining Victorian homes.

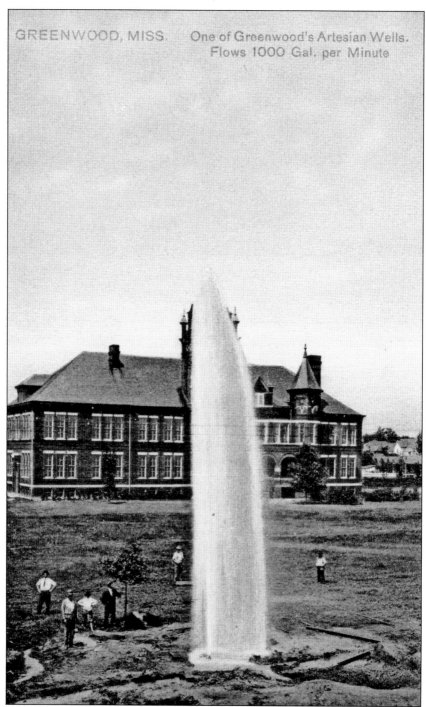

GREENWOOD, MISS. One of Greenwood's Artesian Wells.
Flows 1000 Gal. per Minute

Wright continued to sink wells, including this 1908 gusher just north of Davis School. Eight years later, the local chapter of the Daughters of the American Revolution arranged for a massive granite monument to be placed on the site, complete with fountains for the children to enjoy. After Davis School was lost in a 1980 fire, the fountains were disconnected and the monument moved to its present site a few hundred feet north of the spring.

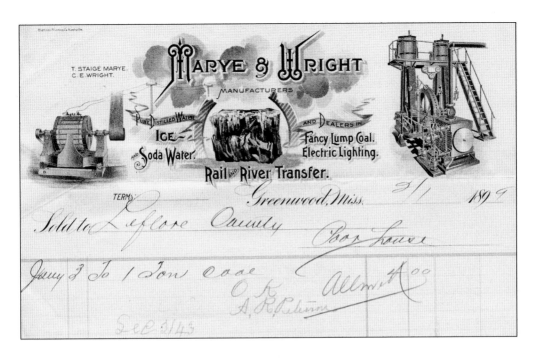

C. E. Wright made several fortunes in light, coal, and ice. Recognizing the appeal of bottled sodas, he acquired the Coca-Cola franchise for the Delta, adding that novelty to his empire of coal-powered electricity and blocks of ice. This remarkable entrepreneur and civic booster was killed by a train in 1920.

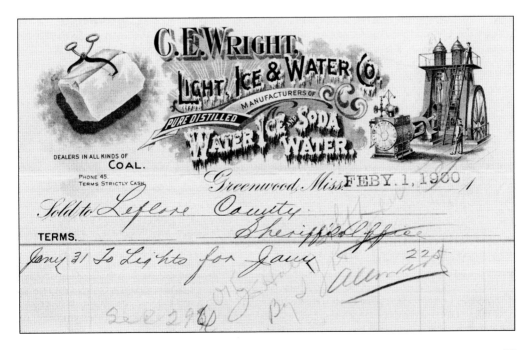

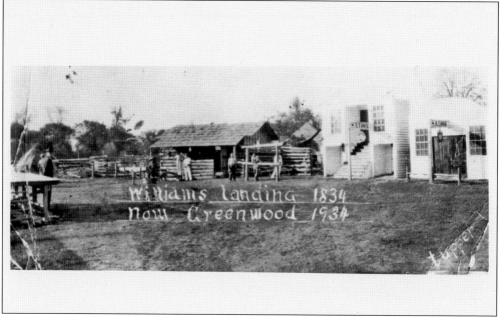

The 1884 photograph on page 21 is one of the oldest depictions of life in Greenwood. That photograph was used as the basis for a Williams Landing Centennial Spring Festival in 1934. Several of the 1884 buildings were recreated just east of the river terminus of Walthall Street. An interesting addition was a Native American teepee and plans for a historically inaccurate battle. The local newspaper, the *Greenwood Commonwealth*, reported, "On Thursday night, the settlement will be attacked by a tribe of wild Indians, who will swoop down upon the little town from the river. The redskins will make their way stealthily up the river in boats and about dusk, they will terrify the unsuspecting settlers with their blood-curdling war whoops and dances performed by the light of flickering torches and blazing bonfires." After the completion of the festival, the log cabin was dismantled, moved to Mississippi Avenue, and reassembled. It served as an "up-to-date night club, catering to the highest class trade." Below is an advertisement for a hopeful Depression-era festival in 1932.

GALA SPRING FESTIVAL
Greenwood, Thursday, April 14th
A FULL DAY AND NIGHT OF FREE ENTERTAINMENT

PARADE OF BEAUTIFUL FLOATS AND TABLEAUX
DANCING TO THE TUNE OF A HOT CHA CHA ORCHESTRA
THE DELTA'S FAIREST IN A FASHION PROMENADE
VAUDEVILLE AND MOVING PICTURES
BOXING CONTESTS WITH FISTIANA'S STARS
TREMENDOUS TRADE EXHIBITS

☞ LOTS OF FREE PRIZES ☜

LAWRENCE-GREENWOOD

Four

HISTORIC HOUSES

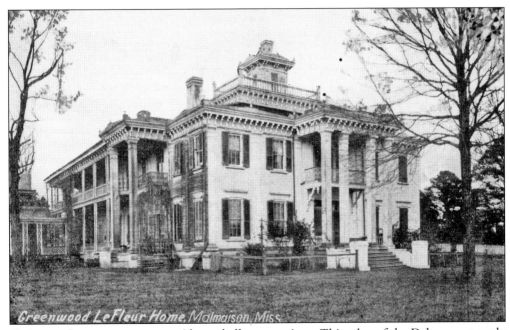

Greenwood LeFleur Home, Malmaison, Miss.

Greenwood was never a town with antebellum mansions. This edge of the Delta was sparsely settled before the Civil War, and those few planters who built grand houses built them up in the hill country, away from the disease and vermin of the lowlands. The most famous house associated with Greenwood was Malmaison, the Italianate/Greek Revival manor of Choctaw chief Greenwood Leflore. It was actually built 14 miles east of Greenwood on Leflore's Teoc Plantation.

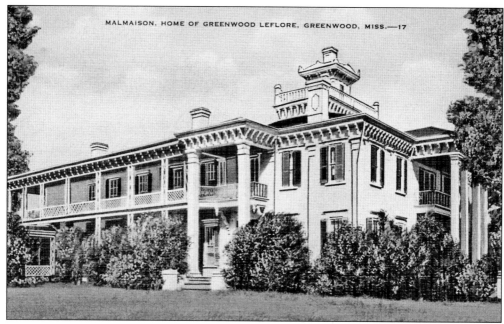

After Greenwood Leflore negotiated the 1830 Treaty of Dancing Rabbit Creek with the U.S. government, he came away with more than 15,000 acres of prime Delta land. He built his own short-lived town, Point Leflore, at the junction of the Tallahatchie, Yalobusha, and Yazoo Rivers and parlayed his holdings into one of antebellum Mississippi's largest fortunes. Much of that wealth was lavished on Malmaison, the palatial home designed by his son-in-law, James Clark Harris. Constructed of pine and cypress lumber cut from Teoc Plantation, Malmaison rivaled the best of Natchez or Columbus in size and detailing. The Greek Revival columns and porticoes were blended with the Italianate Revival bracketed eaves and square cupola to create a unique masterpiece.

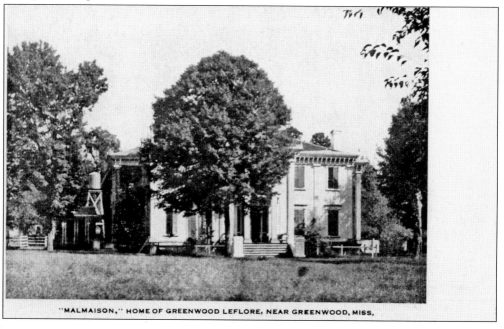

"MALMAISON," HOME OF GREENWOOD LEFLORE, NEAR GREENWOOD, MISS.

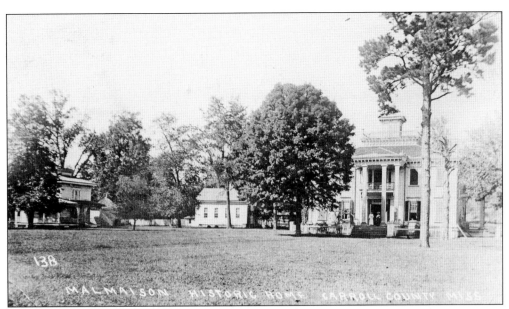

The interior of Malmaison featured two lengthy hallways intersecting in a Greek cross pattern; one stretched 50 feet and the other 65 feet. Fifteen rooms were packed with French antiques, imported carpets, and silk damask window shades. The grounds were equally elaborate, with numerous outbuildings and supporting structures. In the top photograph, the east facade of the house is shown. To the left rear is the detached kitchen; on the far left is a house that likely served the overseer or plantation manager. Barely visible beyond it is one of the garconnieres. Leflore's personal carriage, a luxurious vehicle for its time, was kept in a free-standing carriage house. Fortunately, when Malmaison burned in March 1942, the carriage was pulled away from the flaming mansion and salvaged. It is now on display at French Camp, Mississippi.

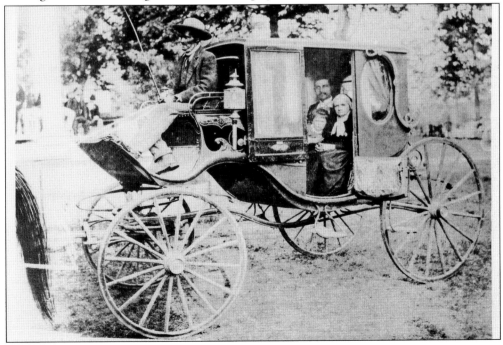

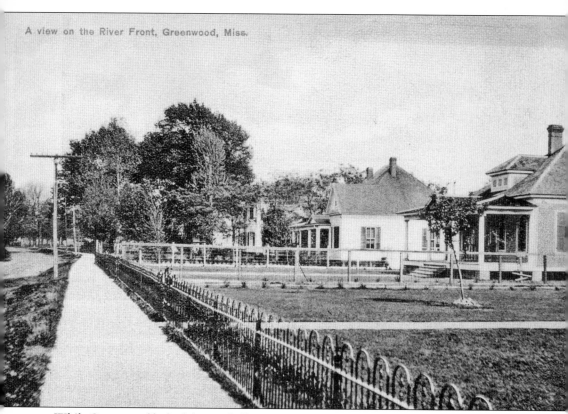

While Greenwood lacked the antebellum grandeur of Natchez or Vicksburg, it did have a history of impressive Victorian, neoclassic, and Colonial Revival homes dating back to the late 1800s. The cotton boom of the 1890s and first decades of the 1900s brought a degree of prosperity to the town that was reflected not only in its civic architecture but also in the private homes of cotton brokers, planters, bankers, and other professionals. Many of these homes have been lost to commercial development and neglect through the years, but others have survived and undergone extensive renovations. One of the most prestigious streets of the last century was River Road, originally known as West Front Street. The houses on the right and in the middle are both gone; the house in the background is the Bridgewater Inn. In the foreground is the most easily identifiable landmark in the photograph, the iron fence that still fronts this home on River Road.

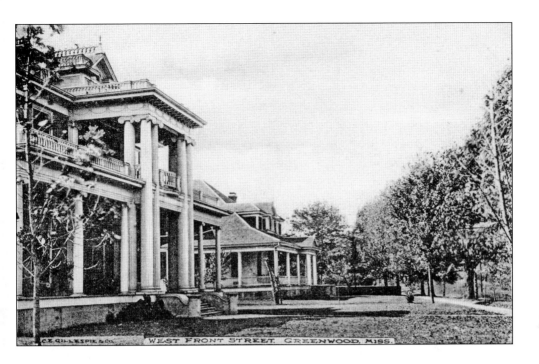

The photographer has turned 180 degrees toward the west, capturing the same tree in the foreground of this shot as was seen across the yard of the previous picture. The Burkhalter House was one of the largest neoclassical mansions in Greenwood, its columns and porticoes visible from across the river. This home and the one just beyond it are still standing but in precarious condition. It appears again as one of the three featured homes in a postcard collage.

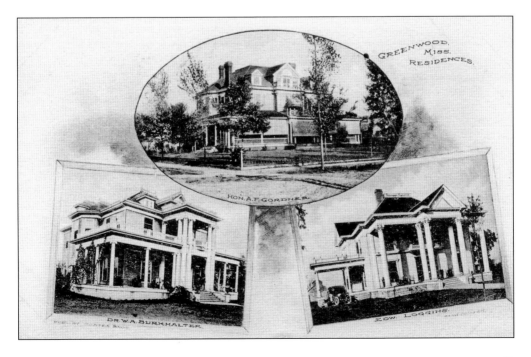

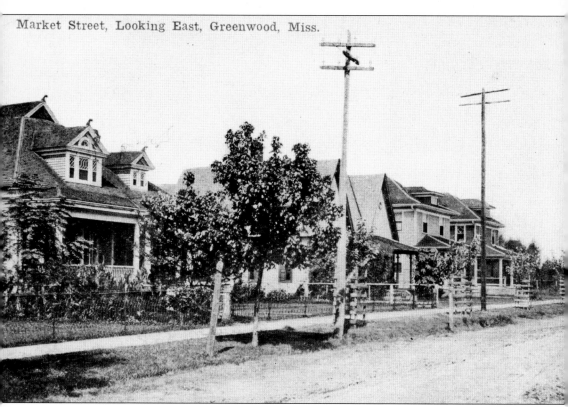

Market Street lies one block south of River Road; its eastern half has always been primarily commercial and the western half more residential. The homes along West Market Street tended to be more modest and utilitarian than those on River Road, but by modern standards they were still very large and comfortable residences. The house pictured in the foreground is extant and served for many years as the parsonage for First Baptist Church. All of the other homes have been lost or drastically altered in the past century. Notice that someone has carefully placed wooden fences around the young trees along the sidewalk.

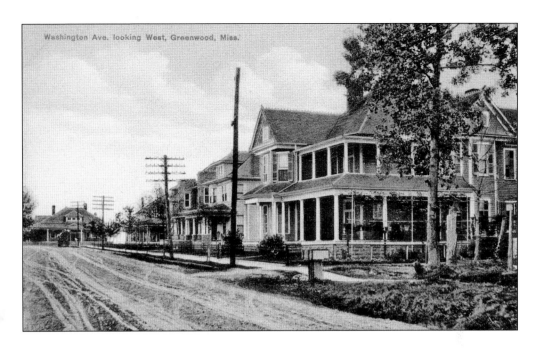

Another desirable address in the early 1900s was West Washington Avenue. Two- and three-story Queen Anne and Classical Revival homes lined the blocks between Cotton Street and Mary Street. The top postcard depicts the north side of the last block of West Washington Avenue, showing several houses that have been torn down or neglected beyond repair in the last few decades. The house on Mary Street in the distance is still standing, as are the last three houses seen here on Washington. The street is still unpaved and shows wagon tracks. The bottom card shows the same homes from the intersection with Mary Street.

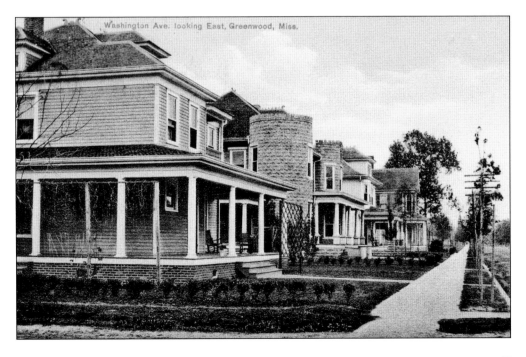

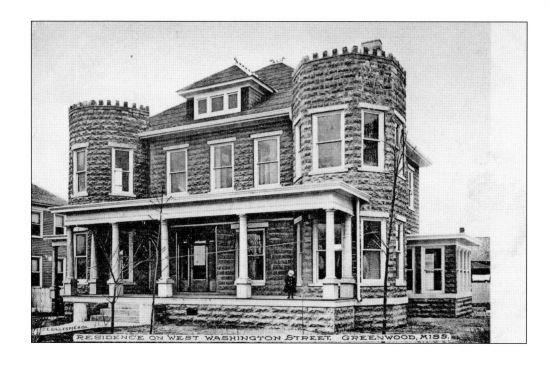

RESIDENCE ON WEST WASHINGTON STREET, GREENWOOD, MISS.

The upper card shows the home at the far end of West Washington, a unique castle-like stone house with twin towers and a deep porch. Pictured below is one of the many nice houses on the tree-lined streets of Greenwood.

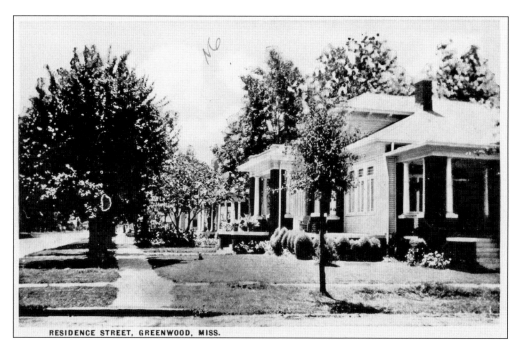

RESIDENCE STREET, GREENWOOD, MISS.

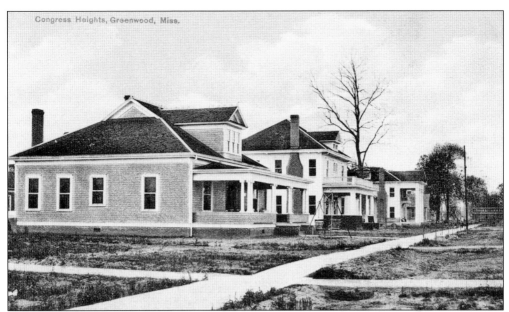

Congress Heights, Greenwood, Miss.

Congress Heights was another upscale part of town, just south of the Columbus and Greenville Railroad. Mississippi Avenue and Parkway and Dewey Streets boasted Colonial Revival, American foursquare, and neoclassic mansions and bungalows, most built between 1910 and 1920. The absence of mature trees in this photograph drastically alters the appearance of the neighborhood. Across the river, North Greenwood was also developing rapidly and capturing much of the upscale real estate market after 1910. Some of the lots on Grand Boulevard were several acres in size, but the side streets that radiated east and west from the boulevard offered smaller parcels. One of the earliest areas to develop was the Wilson Addition, roughly in the present day East Claiborne/Crockett/Bell Avenue neighborhood. This shot is looking west along Crockett Avenue toward Poplar Street. The house in the foreground burned in the late 1950s; the houses beyond it still stand, although several have been drastically altered.

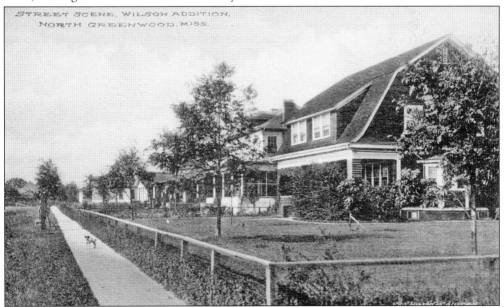

Street Scene, Wilson Addition, North Greenwood, Miss.

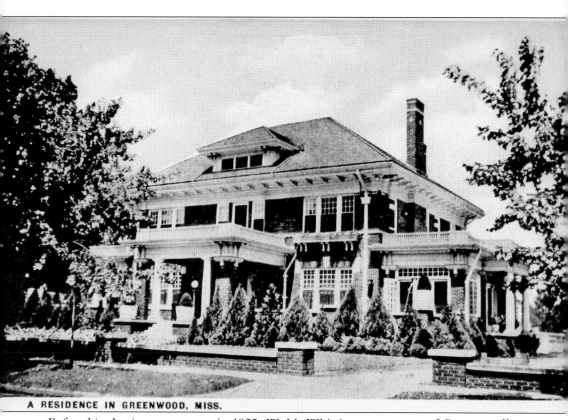

A RESIDENCE IN GREENWOOD, MISS.

Before his election to congress in 1925, W. M. Whittington was one of Greenwood's most successful lawyers. He moved his offices into the old post office building at Market and Fulton Streets, rechristening it the Whittington Building. In 1905, he hired Birmingham architect Bem Price to build a massive neo-Georgian/Prairie-style house on an East Market Street lot where a home had recently burned. The resulting house was notable not only for its size and wealth of details but for the remarkable inclusion of an elevator. It was one of the last large homes to be built in downtown Greenwood, as the Boulevard Subdivision was soon to emerge as the fashionable address. Following the deaths of Congressman Whittington and his wife, the house became the state headquarters of the Mississippi Garden Clubs.

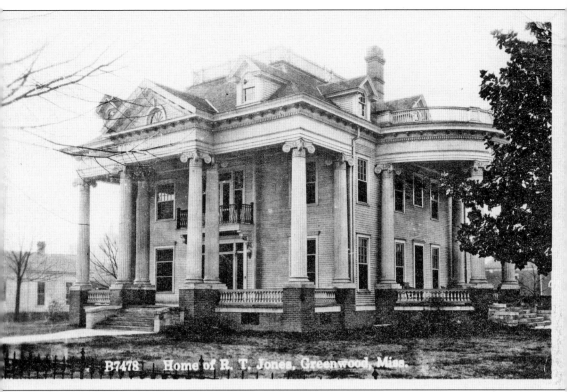

B7478 Home of R. T. Jones, Greenwood, Miss.

R. T. Jones moved an existing house from the southwest corner of Washington and Cotton Streets to the back of his lot in 1909. He then proceeded to build one of Greenwood's most memorable homes, a neoclassic rival to the T. R. Henderson house just across the street. Full-height columns with Ionic capitals supported the massive entablature and semicircular portico; those columns came to be known as "the Twelve Apostles." This house would dominate the corner long after the Henderson House had been demolished, but its days as a private residence were not lengthy. By the 1950s, it had been converted into Wilson and Knight Funeral Home. When that business moved to Highway 82 in the 1970s, the old house found new life as the first home of Cottonlandia Museum. It was later cut into sections and moved across both the Yazoo and Tallahatchie Rivers to a new location off Money Road.

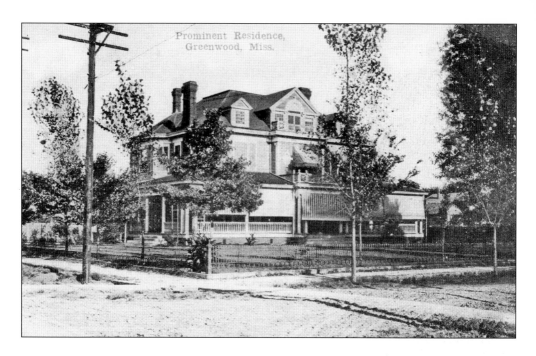

The house in the top photograph is Judge A. F. Gardner's home, located on the southeast corner of Market and George Streets. The rambling three-story residence cost $9,800 to complete in 1904, an extraordinary sum for the time. It was unfortunately demolished in the 1960s and replaced with the South Central Bell building. The house in the bottom photograph, likewise labeled "Prominent Residence," was the W. W. McNeill home at 509 East Washington Avenue. McNeill was the vice president of the hardware store at the northwest corner of Howard and Washington Streets.

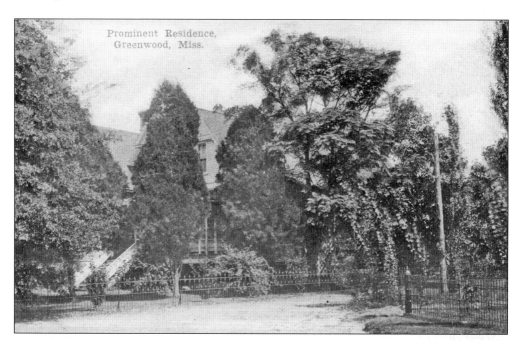

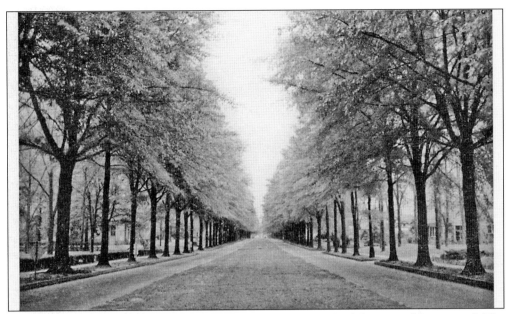

Grand Boulevard was a carefully planned and heavily marketed subdivision of Greenwood. The Village of North Greenwood, with only a couple of hundred residents, was incorporated in 1906. Just four years later, three Greenwood businessmen laid out their plans to sell estate lots along a road that would stretch through the old George Plantation, running approximately a mile from the Yazoo to the Tallahatchie. Sally Humphreys Gwin, the wife of one of these entrepreneurs, expanded on their scheme by convincing them to make the road an 80-foot-wide boulevard, lined on both sides with pin oaks. She personally supervised the transplanting of those young trees from the Tallahatchie riverbanks to carefully spaced sites along Grand Boulevard. By mid-century, the oaks had grown into towering giants, meeting in an unbroken arch along one of the most outstanding residential streets in America. "Miss Sally" was honored by the Department of the Interior for her role in creating Grand Boulevard.

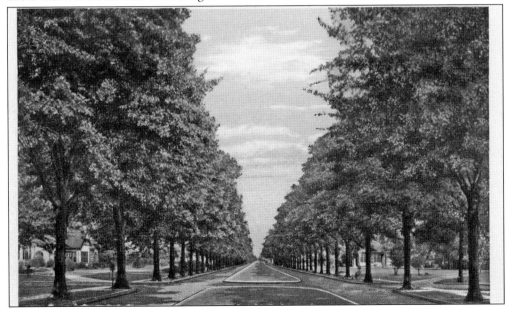

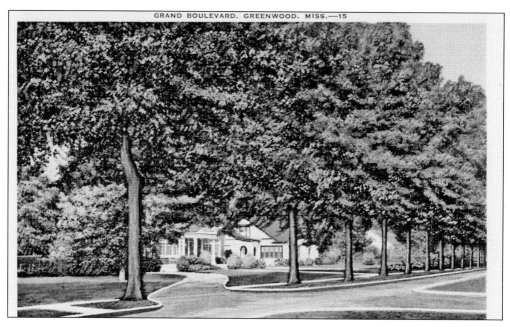

"Miss Sally's trees" were dug up from along the Tallahatchie riverbanks and the Pillow Plantation west of Greenwood. Horace Greeley Austin was the foreman for the project, and he labored for years to please the relentless perfectionist Sally Gwin. The trees were placed in symmetrical ranks along the entire mile of Grand Boulevard, even though it was obvious that some would be cut down as side streets developed. The houses that were built along this remarkable road range from modest bungalows to Tudor manors and neoclassic mansions. Over the past century, many of the oaks have succumbed to disease and storm damage, but the survivors can be found in every block of the boulevard and down many of the side streets.

Five

CHURCHES AND SCHOOLS

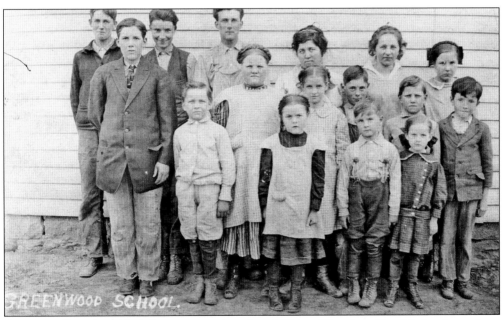

Greenwood's various Christian congregations shared Union Church on East Market Street from the 1840s to the 1880s. As their numbers grew, each denomination pulled away and built their own church facilities. Schools were not funded nearly so quickly; an 1860s-era frame schoolhouse on Cotton Street was in such deplorable shape by 1900 that the *Commonwealth* lobbied hard for a replacement: "The present [school] building is inadequate, unsuited, unfit for the purposes for which it is used. . . . Some of our prominent parsimonious citizens . . . were after avoiding tax paying, and this old makeshift is the result." The date and specific school pictured here are unknown.

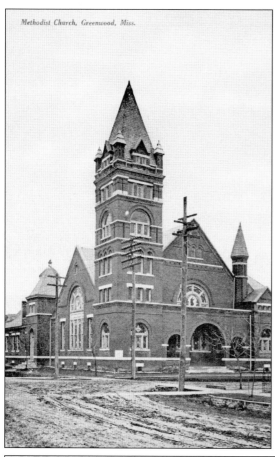

Methodist Church, Greenwood, Miss.

The Methodists of Union Church were one of the first congregations to leave the ecumenical facility and build their own sanctuary. The black Methodists, many of whom were freed slaves, had already departed to form Wesley Methodist Episcopal Church. Soon after, the white Methodists also broke away from Union Church, supposedly after tiring of Presbyterian literature. They purchased a lot at the southeast corner of Fulton and Washington Streets and built a small steepled church there. The bells in that early church's belfry, rung by a frantic Nannie Cox, alerted the townspeople on the April 1890 night when fire engulfed the downtown district. Eight years later, the Methodist congregation voted to build a $12,000 structure one block to the west on Washington Street. Revered architect R. H. Hunt drew up the plans, and work got underway in the fateful summer of 1898, just as yellow fever was ravaging the Delta. Progress slowed with quarantines and evacuations, but the sanctuary was dedicated in June 1899.

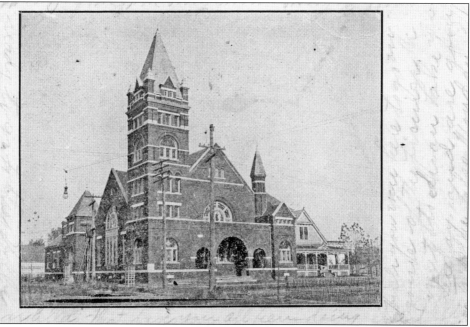

First Methodist Church, at Greenwood, Miss.

R. H. Hunt's design for Greenwood's First Methodist Church was remarkably ambitious for a small congregation in a small town. Two hundred and sixty-five members took on the payments for a project that soared from the original estimates of $12,000 to $20,000. The end result, still standing at the northeast corner of West Washington and Cotton Streets, is one of Mississippi's most outstanding Romanesque Revival churches, complete with towers, minarets, and semicircular archways. Lining the sidewalk are original hitching posts, enduring reminders of the horse-and-buggy era during which this church was built. The overall appearance of the church has been changed only minimally in a century's time.

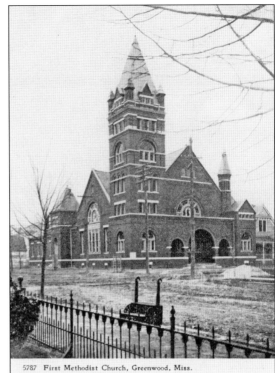

5787 First Methodist Church, Greenwood, Miss.

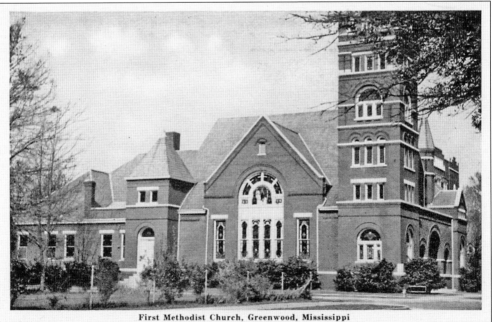

First Methodist Church, Greenwood, Mississippi

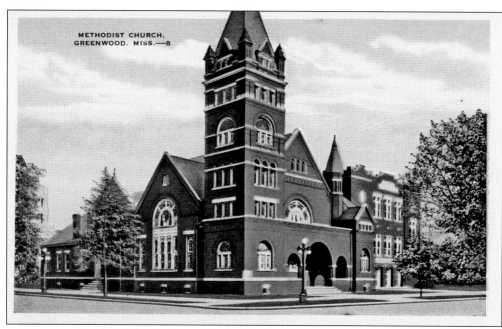

METHODIST CHURCH,
GREENWOOD, MISS.—8

In 1924, Frank McGeoy, architect for a number of significant downtown businesses and homes, designed the adjacent educational building for First Methodist. Its shaped parapet, projecting end bays, and central stone diamonds blend in with the 1899 sanctuary structure so smoothly it's as if they were built simultaneously. The opening of the education annex allowed the men's Sunday school class to move out of their old meeting space, a room high in the main tower. In photographs on the preceding pages, the parsonage, which was torn down for the educational building, can be seen.

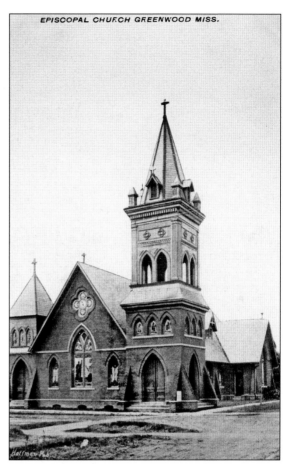

The Episcopalians had abandoned Union Church several years before the Methodists took their leave. In 1881, four families met to lay out plans for an Episcopal sanctuary, and within a year, the tiny congregation moved into its first real church home just south of where city hall is now located. Less than 20 years later, with a somewhat larger group of communicants, the Church of the Nativity bought the Opera House lot at the southwest corner of Church and Howard Streets. The vestry announced plans for "a suitable brick church . . . not to cost less than $4000." Their ambitions got ahead of their budget, and the lot was sold off for back taxes without so much as a brick laid. By 1902, the lot had been reclaimed. Several stained-glass windows were relocated from the old Main Street church, and the deed to that property was conveyed to the Jewish congregation. The first Eucharist at Nativity was observed in August 1902. The Rose Community Building was added in the 1920s.

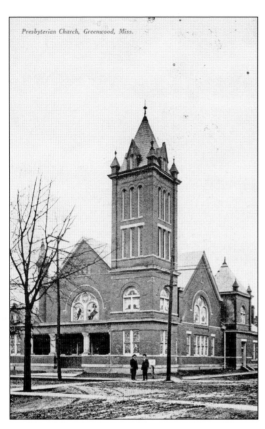

Presbyterian Church, Greenwood, Miss.

After the departure of the Methodists and Episcopalians, Union Church was Presbyterian by default. The old building was inadequate for even one congregation, and the remaining members sold it in 1887. It was moved east on Market Street, and the Presbyterians built a new church on the site of the original. Fourteen years later, the new church was destroyed by a Sunday morning fire. The Jewish congregation, having recently moved into the old Episcopal church, graciously offered to share their space with the now-homeless Presbyterians. The offer was accepted, and the sanctuary hosted the Jewish believers on Saturday and the Christians on Sunday until a new First Presbyterian Church could be built at the southwest corner of Main and Washington Streets. The members moved into it in 1905 and added a new sanctuary in 1926.

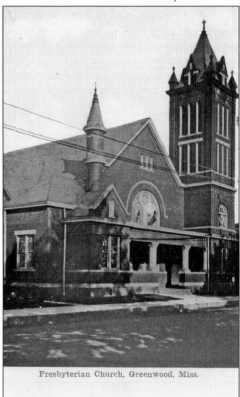

Presbyterian Church, Greenwood, Miss.

78

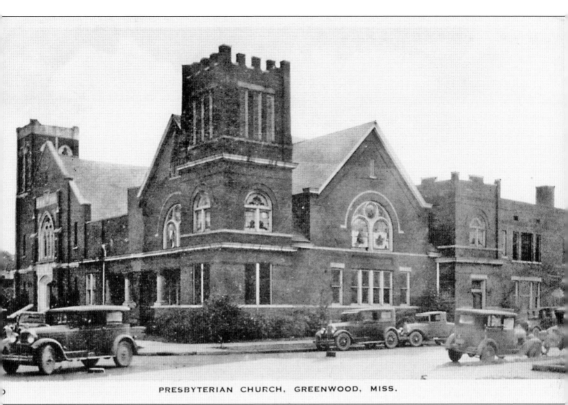

PRESBYTERIAN CHURCH, GREENWOOD, MISS.

S. G. Beaman served as the contractor for First Presbyterian's 1926 sanctuary; the original building was converted into a Sunday school wing. The first services in the current church were held on January 10, 1926. During the renovations, the corner tower of the 1905 church was replaced with a shorter square tower, and the small pointed minaret on the left side of the old building disappeared. A bell from Greenbriar Plantation was installed in the main tower in the 1960s.

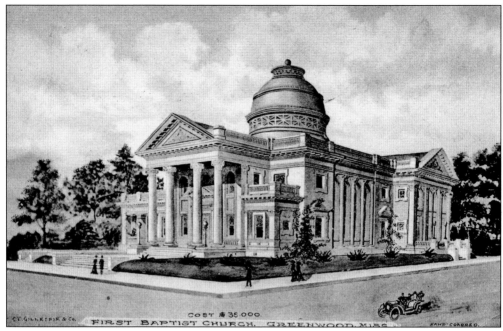

COST $35,000.

FIRST BAPTIST CHURCH, GREENWOOD, MISS.

The Baptists also participated in Greenwood's multidenominational Union Church, but their first independent move was to the 1879 courthouse. This arrangement must have been unacceptable, as there is no record of Baptist services from 1880 to 1887. By 1894, there were enough interested members to build a Gothic chapel in the 400 block of Howard Street, just south of the old post office. According to the *Greenwood Enterprise* April 12, 1895, the frame church was completed and dedicated in April 1895 with plans for "a protracted meeting . . . to last a week or more." Less than 12 years later, First Baptist had outgrown this modest space and began work on a West Washington Street church that rivaled First Methodist in size and detail. The old Howard Street church was converted into a rooming house and demolished by 1915.

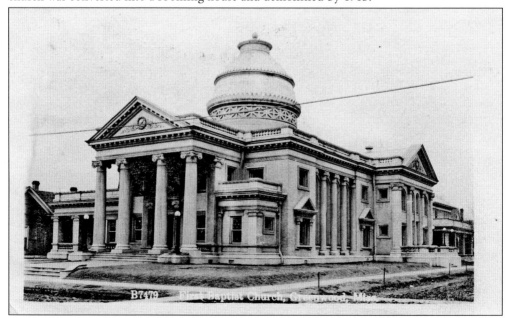

B7479 First Baptist Church, Greenwood, Miss.

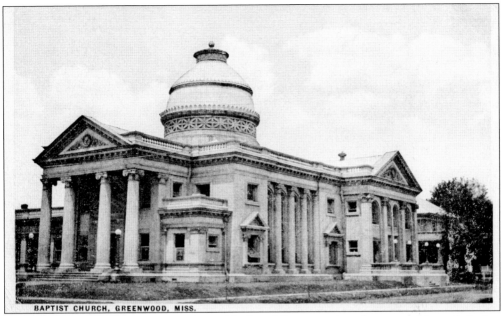

BAPTIST CHURCH, GREENWOOD, MISS.

First Baptist's members took a huge leap of faith and finances when they moved from their tiny Howard Street chapel to the massive sanctuary on West Washington Street. Thirty thousand dollars was pledged in one enthusiastic Sunday morning service, led by Pastor S. E. Tull and the indomitable Lizzie George Henderson. The Hendersons donated the church's lot and may have originally intended to see it built on the corner where the library and Confederate Memorial Building stand. Regardless, the resulting building was an imposing landmark with classical porticoes and a shining silver multi-stage dome. In the top photograph, the original parsonage is visible behind the church; it was never inhabited by Dr. Edward Caswell, who spent his 21-year tenure as pastor living in the Hotel Irving. Below is either a mistakenly reversed negative or a photograph of a similar church; two were known to be built by the same architect in Louisiana and Texas.

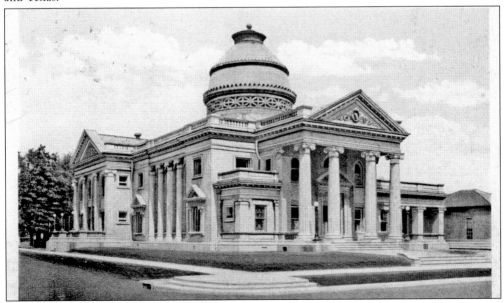

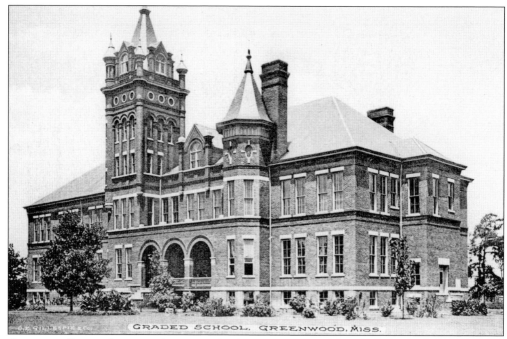

Greenwood's population explosion in the first decade of the 1900s rendered the one-room, 1860s-era Cotton Street school obsolete. A successful $15,000 bond issue was passed in 1904, and Chattanooga architect R. H. Hunt (who was also responsible for First Methodist Church and the courthouse) returned to Greenwood to design a massive castle-like school. Contractor J. F. Barnes of Greenville oversaw the actual construction, which resulted in a stunning two-story brick edifice, complete with towers, turrets, and a famously creepy basement. These 1910 fourth-graders were in one of the first classes to attend Jefferson Davis School from 1st through 12th grade.

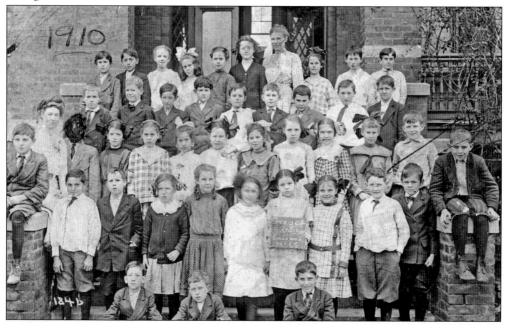

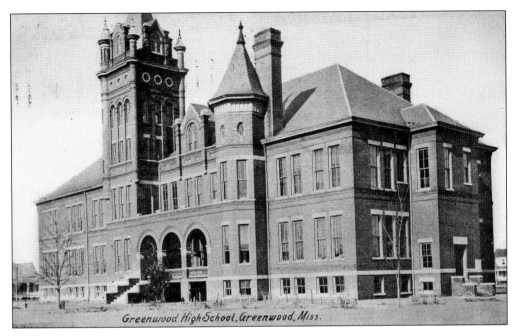

Greenwood High School, Greenwood, Miss.

For the first 10 years of its existence, Jefferson Davis School served grades 1 through 12. It occupied a 10-acre lot bounded by the Southern Railway tracks, Dewey Street, Cotton Street, and Church Street. The football field was immediately south of the school. The first floor originally held six classrooms and offices; the second floor featured two more classrooms, libraries, and an auditorium. Every classroom included a cloakroom, and the basement was divided into playrooms for boys and girls, along with the furnaces. Eventually the large square tower was shortened and interior alterations were made as two other academic buildings joined the original structure on the campus.

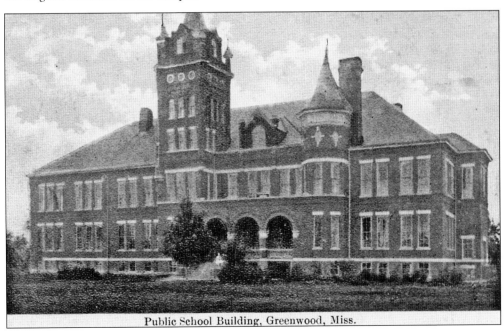

Public School Building, Greenwood, Miss.

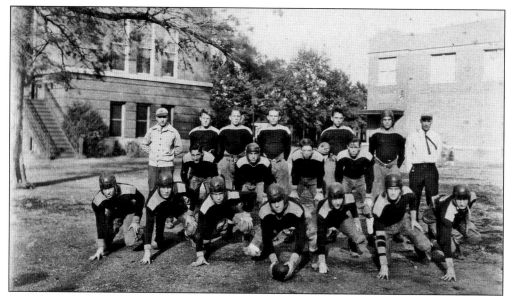

The 1927 Greenwood High School team included, from left to right, (first row) Johnny Wiggins, Howard Lewis, Porter Peteet, Lawrence Morgan, Pete Connell, John Ashcraft, and Edwin Bell; (second row) Ira Boswell, George Taylor, Walter Walt, and Henry McCabe; (third row) unidentified coach, John Stokes, Prince McShane, Cunliffe McBee, Orman Kimbrough, Walter Pillow, and an unidentified coach. In 1911, plans were laid for a second Davis School building on the north side of the academic campus. The 10-year-old building was seriously overcrowded, and a structure dedicated to upper grades was desperately needed. The three-story brick structure was completed in 1914, and it is labeled "High School" here. According to the *Greenwood Commonwealth* October 6, 1911, the ground floor originally held a gymnasium, dressing rooms, "domestic science [and] manual training rooms," and the boilers. After the completion of the 1924 Greenwood High School next door, those basement spaces were converted to a cafeteria. (Below, courtesy of Imogene Lewis.)

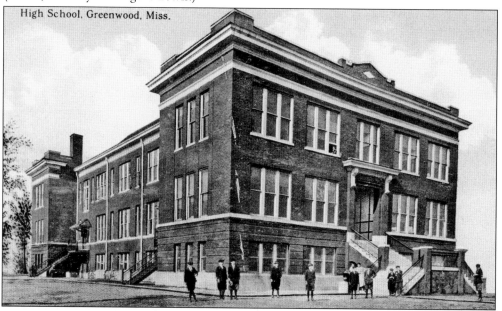

High School, Greenwood, Miss.

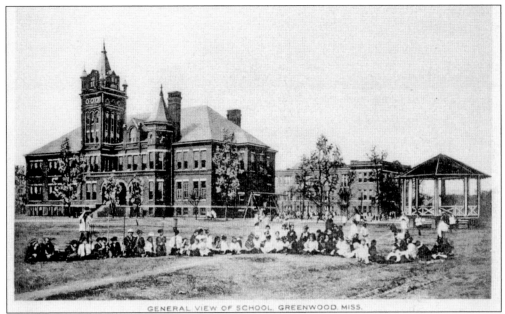

GENERAL VIEW OF SCHOOL, GREENWOOD, MISS.

This post-1915 view shows both of the original Davis School buildings, the 1904 structure in the foreground and the 1914 addition to the rear. A large group of students are arrayed on the football field, and the bandstand is visible on the right. It was later moved to the southwest corner of the courthouse lawn and then to City Park, where it eventually deteriorated and was demolished. The aerial view, likely taken from the utilities water tower, looks out over the Davis School campus and is dated to the period between the completion of the second school building (1914) and the addition of the bandstand (1915). The 1904 Davis School was still in use in December 1980, when it was destroyed by fire. Its counterpart, the 1914 school, was torn down a few years later, to be replaced by a bland one-story complex.

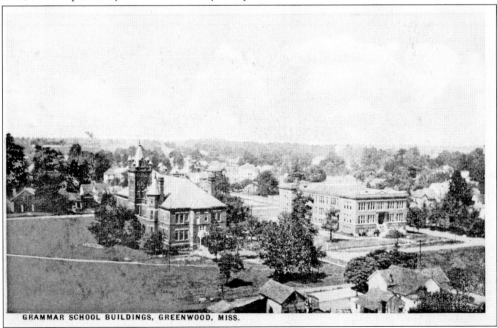

GRAMMAR SCHOOL BUILDINGS, GREENWOOD, MISS.

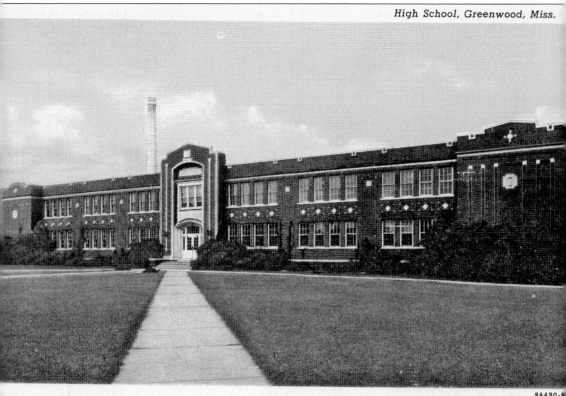

9A490-

On May 26, 1924, a $200,000 bond issue was overwhelmingly approved by Greenwood's voters. The funds were designated for the new Greenwood High School, an East Greenwood elementary school, completion of the North Greenwood School, and additional classroom space for black students. Frank McGeoy designed the high school, a reflection of Greenwood's prosperity and academic standards. In the 1920s, towns all over Mississippi were funding new high schools, and this was to be one of the finest and most architecturally outstanding examples of that commitment to education. Construction was underway by September 1924 and completed by January 1925. The high school students moved over from the 1914 Davis School building in time for the spring semester. These photographs reveal a building that is almost identical to the structure as it stands today. It served as Greenwood High School from 1924 until 1959.

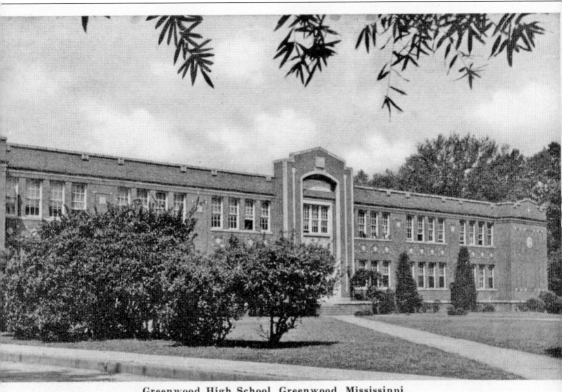

Greenwood High School, Greenwood, Mississippi

For 35 years, the campus of Greenwood High School buzzed with activity and served as the center of the community's academic and sports emphasis. Football games were played on the broad field between Davis School and the railroad tracks until Bulldog Stadium was built in the 1950s. The 900-seat auditorium hosted plays, concerts, and graduation ceremonies throughout its time as the high school and the decades when the building served as Greenwood Junior High School. On the 1934 night when Greenwood celebrated its centennial with a spring pageant, organizer Will Vardaman Jr. was killed when he dashed out the front doors of the high school and slammed headfirst into the flagpole on the front lawn.

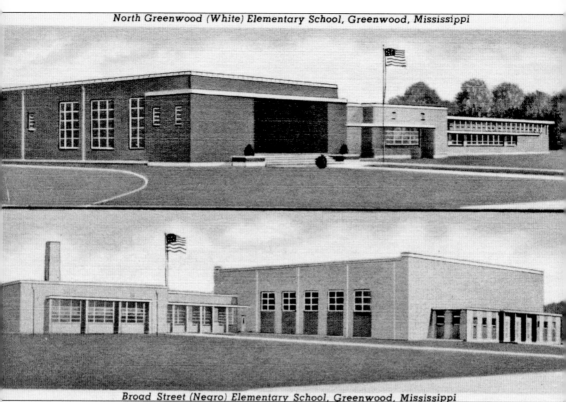

North Greenwood (White) Elementary School, Greenwood, Mississippi

Broad Street (Negro) Elementary School, Greenwood, Mississippi

This 1950s postcard illustrates two brand new and seemingly similar elementary schools on opposite sides of Greenwood. No evidence if given of the brewing storm over separate-but-equal facilities that would soon impact Greenwood, the state of Mississippi, and the nation. North Greenwood Elementary was built on land donated by Sam Gwin (one of the original Grand Boulevard developers) at the corner of Rosemary Lane and the boulevard. It replaced the old two-story school, which had stood for several decades on Poplar Street between East Adams and East Monroe Avenues. In 1964, North Greenwood Elementary was renamed Kathleen Bankston Elementary in honor of its long-time principal. Broad Street Elementary was later expanded to become Threadgill High School, which served the black community until full-scale integration was implemented in 1970.

Six

Banks and Businesses, Hotels and Hospitals

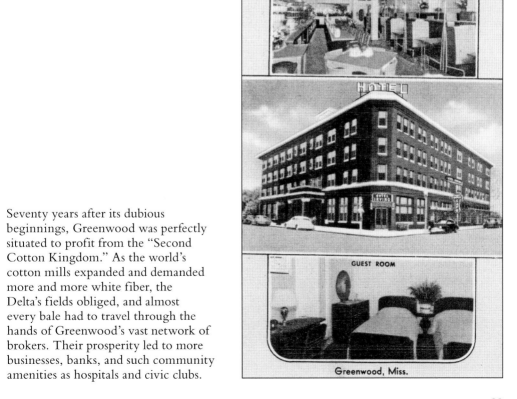

HOTEL IRVING,

POST OFFICE CAFE

GUEST ROOM

Greenwood, Miss.

Seventy years after its dubious beginnings, Greenwood was perfectly situated to profit from the "Second Cotton Kingdom." As the world's cotton mills expanded and demanded more and more white fiber, the Delta's fields obliged, and almost every bale had to travel through the hands of Greenwood's vast network of brokers. Their prosperity led to more businesses, banks, and such community amenities as hospitals and civic clubs.

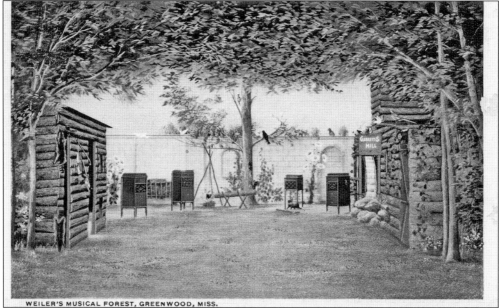

WEILER'S MUSICAL FOREST, GREENWOOD, MISS.

Albert Weiler was an East European Jewish refugee who found his way to Greenwood in 1880 riding a pack mule loaded down with jewelry, embroidered items, and china. Luxury-starved Deltonians welcomed him with open wallets, and he quickly established himself as one of the state's best businessmen. The mule was soon put out to pasture as Weiler moved from storefront to storefront, each time expanding and diversifying his offerings. In 1897, he opened Weiler's Jewelry Palace in the 200 block of Howard Street. The business moved into the two-story Bew Building in 1900, and Weiler soon unveiled The Musical Forest, an elaborate display area of cabins, trees, and forest animals interspersed with Edison record players. On Christmas Eve 1934, the second floor was destroyed by fire, thought to have been started by errant firecrackers. Odean's Cafeteria, in the adjoining half-block, had previously housed the Post Office Cafe and Gelman Fine Foods.

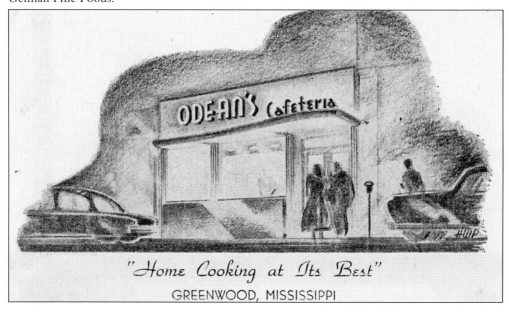

ODEAN'S Cafeteria

"Home Cooking at Its Best"

GREENWOOD, MISSISSIPPI

Weiler's success attracted other Jewish refugees to the Delta. The Kantrovitz brothers took over one of the Market Street storefronts that Weiler had outgrown, showcasing their men's clothing and tailoring talents. They would legally shorten their name to Kantor a few years later. As brick commercial buildings replaced houses in the 300 block of Howard Street, J. Kantor contracted with Dye and Pittman of Coffeeville to build a two-story enameled brick store. Frank McGeoy designed the structure and oversaw its construction in 1917. Ten-year-old Adeline Kantor laid the first brick into place early on a Tuesday morning in March; five months later, the store opened for business. J. Kantor, "Outfitter to Mankind," would be a fixture on Howard Street for more than 70 years. Three blocks south, Quinn Drug Company manufactured a number of pharmaceuticals in their massive triangular factory.

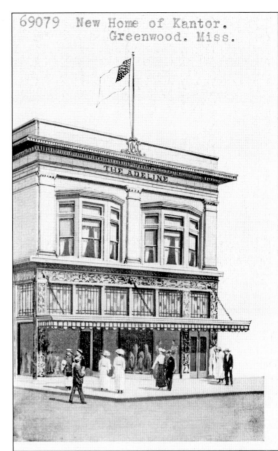

69079 New Home of Kantor. Greenwood. Miss.

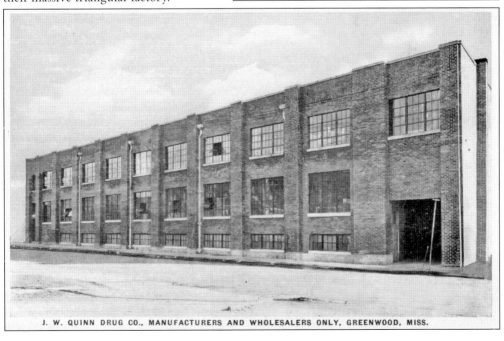

J. W. QUINN DRUG CO., MANUFACTURERS AND WHOLESALERS ONLY, GREENWOOD, MISS.

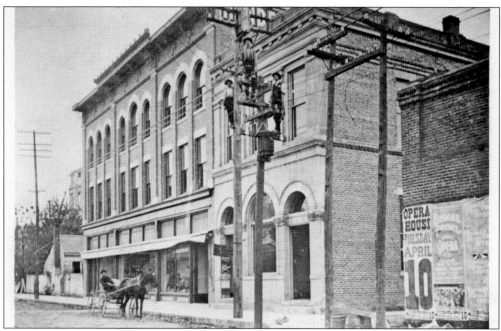

Dr. T. R. Henderson seemed to have his hand in every civic, philanthropic, business, and banking concern that developed in Greenwood's new century. Henderson and Baird Hardware, one of his many commercial interests, began in a large Market Street building just south of the McBee Building. When the success of that venture outstripped its space, Doctor Henderson purchased a lot around the corner on Market Street. Plans were laid to construct the state's largest retail establishment in 1904. Despite its huge size, it still wasn't big enough to sell Doctor Henderson's automobiles, so even more space was found in the old Austin and Fountain store in the 200 block of Howard Street. In 1907, the Hippodrome Skating Rink opened on the top floor of the Henderson and Baird building, boasting more than enough room for the 450 skaters who showed up on opening night for 15¢ skate rentals. Next door, Doctor Henderson chaired the board of the Bank of Commerce. Around the corner on Howard Street, the post-Depression Bank of Greenwood took in several old buildings as it expanded.

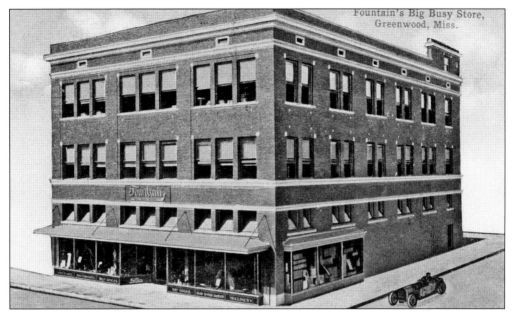

W. T. Fountain began his retail business in Greenwood with partner F. R. Austin in the 200 block of West Market Street. He later went solo and moved to the northeast corner of Howard and Washington Streets in 1902. Twelve years later, he had purchased the lot on the opposite corner, demolished the house that occupied it, and revealed plans to build the largest dry goods and clothing store in the Delta. Fountain's Big Busy Store was a $40,000, three-story wonder with over 22,000 square feet of floor space, an elevator, and plate glass windows that showcased the offerings inside. When the doors were unlocked in September 1914, hundreds of shoppers poured in to marvel at the ladies' wear, millinery, luggage, toys, home furnishings, glassware, china, and the "snug corset try-on nook." Fountain's quickly gained a reputation as the premier shopping destination between Jackson and Memphis. W. T. Fountain died unexpectedly just five years after the opening of his iconic store. The business held on until the late 1950s. Notice the turreted Fountain home behind the store.

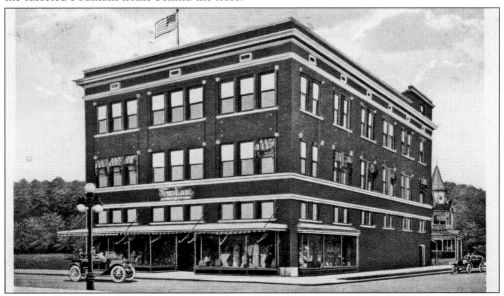

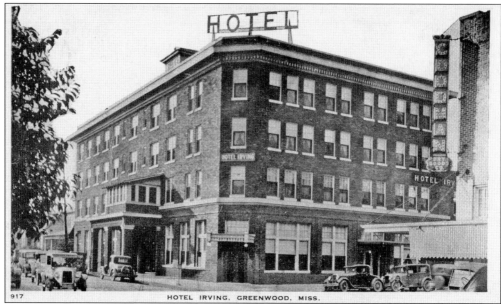

HOTEL IRVING, GREENWOOD, MISS.

All this cotton, banking, and retail business drew visitors, salesmen, and leisure travelers into Greenwood. In the first few decades of the century, they arrived by train as frequently as by car, and several downtown hotels sprang up to meet their needs. The most luxurious was the Hotel Irving, built by Joe Stein in 1916–1917. Stein had moved the Warner Wells home off the lot and hired Garber Construction of Jackson to erect his four-story, 85-room hotel. The grand opening in April 1917 offered 150 carefully chosen guests a night of dancing to the Big Six Orchestra and dinner in the private dining room. Stein, his wife, and his son, Irving, lived in a suite of rooms on the second floor of the hotel with a small porch overlooking Church Street. The hotel gradually lost business to newer highway motels and closed its doors for good in the 1970s. It stood empty until Viking Range Corporation renovated it as the Alluvian Hotel.

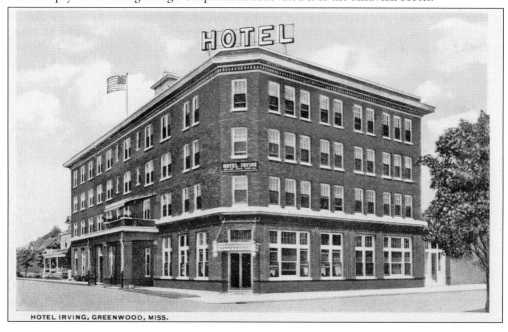

HOTEL IRVING, GREENWOOD, MISS.

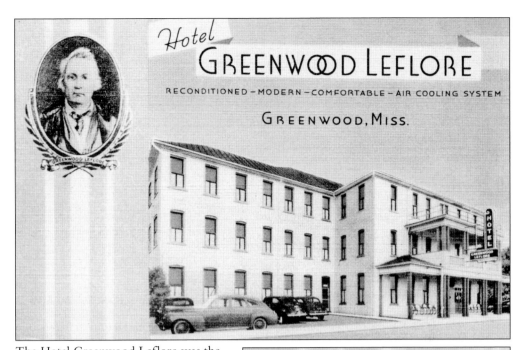

Hotel GREENWOOD LEFLORE

RECONDITIONED – MODERN – COMFORTABLE – AIR COOLING SYSTEM

GREENWOOD, MISS.

The Hotel Greenwood Leflore was the successor to the Reiman Hotel, which had stood on the riverfront between Fulton and Howard Streets since 1889. The original Reiman burned in 1897. According to *The Delta Flag* May 7, 1897, its replacement, designed by R. H. Hunt, was run by "Mrs. Reiman, assisted by her son Harry and two charming and accomplished daughters . . . Misses Flora and Esther." Max Williams purchased the aging hotel in 1937 and had architect R. J. Moor refurbish and enlarge it to compete with the Hotel Irving. Each guest room was remodeled with its own closet and bath, air-conditioning was installed, and a coffee shop opened off the lobby. Renamed the Hotel Greenwood Leflore, it enjoyed a steady clientele until the 1960s, when competition from more modern motels drained its customers away. In the late 1960s, a Grenada bank purchased the hotel and tore it down.

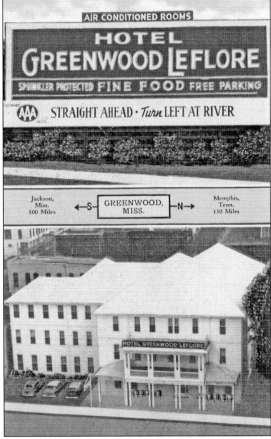

AIR CONDITIONED ROOMS

HOTEL GREENWOOD LEFLORE

SPRINKLER PROTECTED FINE FOOD FREE PARKING

STRAIGHT AHEAD · Turn LEFT AT RIVER

| Jackson, Miss., 100 Miles | ←S– | GREENWOOD, MISS. | –N→ | Memphis, Tenn., 130 Miles |

NAAMAN'S MOTEL, HIGHWAY 82, GREENWOOD, MISS.

The Hotel Irving and Hotel Greenwood Leflore were the showplaces of downtown Greenwood. Kitchell's Hotel (later the Midway) was a bit cheaper, charging only $1 per night in the 1920s. The Sturgis House on Main Street and Mrs. Crull's boardinghouse on the corner of Fulton and Washington Streets offered more long-term accommodations. In the post–World War II era, motor hotels began to spring up along Highway 82 and 49, and their competition would eventually doom the downtown hostelries. Naaman's Motel stood on West Park Avenue, which served as the business route for both of those highways before the bypass was completed. It was later converted to an office park. Folbe's Court, also on Park Avenue, was a tiny motor court, which was demolished in the 1960s.

In the 1950s, national chain motels followed the developing interstate highway system and eventually wound up in every small town. Holiday Inn founder Kemmons Wilson was a former Greenwoodian who opened the first of thousands of motels in Memphis. The Greenwood franchise was ideally located at the south end of the 1954 Hinman Bridge, just across from Greenwood Leflore Hospital. The Travel Inn was one of several 1960s–era motels to cluster a bit further south on the new Highway 49-82 bypass.

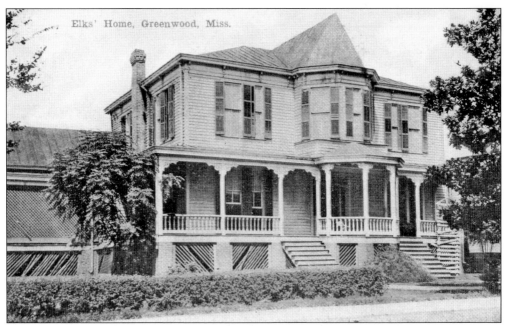

Elks' Home, Greenwood, Miss.

Lodges and fraternal orders were exploding in popularity in the early 1900s, and any ambitious young man was wise to claim membership in as many of these organizations as possible. Greenwood's chapter of the Benevolent and Protective Order of Elks, Lodge No. 854, swelled to over 100 members within a year of its 1903 founding. These men were successful businessmen, bankers, and cotton factors, and they easily raised enough capital to buy the Selliger house on the northwest corner of Main and Washington Streets for $6,000. They met there for nine years before having the house moved down Main Street. R. H. Hunt, who had already designed the Leflore County Courthouse, First Methodist Church, and Davis School, was brought in to design a manor-like downtown lodge for the Elks.

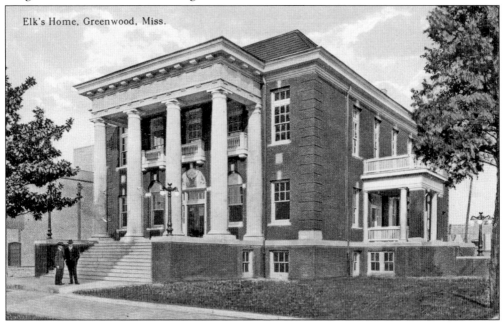

Elk's Home, Greenwood, Miss.

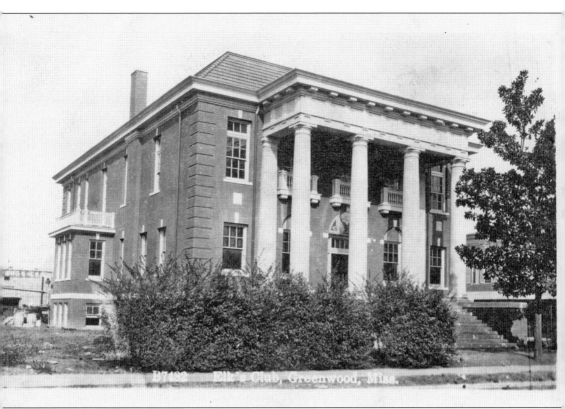

Rising two stories above a full basement, the new Elks Club dominated the corner of Main and Washington Streets just across from the First Presbyterian Church. Its giant-order columns were topped by a full entablature and classical triglyphs and metopes, details usually reserved for civic buildings and churches. Over the main entrance was an intricately detailed tile mosaic elk's head. Inside, billiard rooms, reception halls, a library, a kitchen, and offices filled the first floor. Upstairs was the grand ballroom, the site of Greenwood's annual Cotton Ball for many years. Changing times saw the Elks' membership dwindle, and the upkeep of this enormous building become increasingly problematic and expensive. In 2008, the hall was sold to Viking Range Corporation.

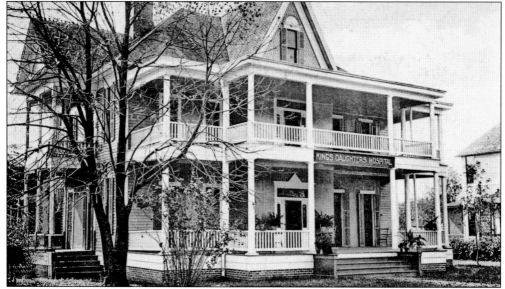

Until the first years of the 20th century, Greenwood lacked anything even resembling a hospital. Patients were treated in their homes, if at all; hygiene and advanced medical care were simply not available. A group of local matrons took matters into their own hands and formed the Kings' Daughters Circle. A "cottage hospital" was set up in a West Washington Avenue home, providing a handful of beds and minimal facilities. They then petitioned the city and county for $7,000 to buy and equip the Bew House at 807 River Road; in 1908, it was converted into Greenwood's first true hospital. Within a decade, the rapidly growing city had outgrown that building's capacity, and $40,000 was designated for a new, state-of-the-art hospital several blocks west of the Bew House. The three-story brick structure opened in April 1918 and welcomed its first baby, Jessye Evans, just a few days later. Remodeling in 1936 allowed the hospital to function until 1952, when services were moved further down River Road. After a quarter of a century of neglect, it was pressed into service again as a temporary home for county government offices.

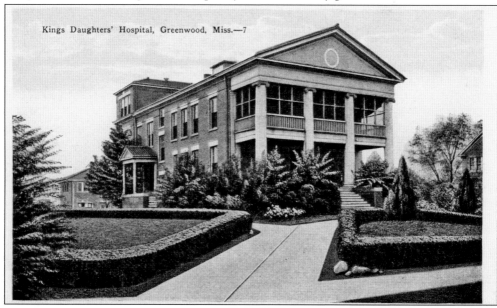

Kings Daughters' Hospital, Greenwood, Miss.—7

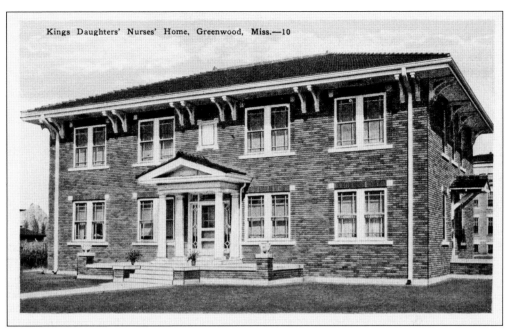

Kings Daughters' Nurses' Home, Greenwood, Miss.—10

Located just behind the 1918 hospital, the Lois Aron Nurses' Home was a gift to the City of Greenwood from Jacob Aron and his wife, Hortense. Aron was a Greenwood native who had relocated to New York City and accumulated a considerable fortune. After their 10-year-old daughter, Lois, died, the Arons memorialized her by building a two-story dormitory for nursing students in Greenwood. From its completion in 1920 until the demise of the nursing program in 1964, the nurses' home housed hundreds of young women from all over the state. This photograph shows the original building; wings were added in later years, creating a large dormitory-style facility. Many of them worked in the new Greenwood Leflore Hospital, which opened in 1952 one block west of the 1918 hospital.

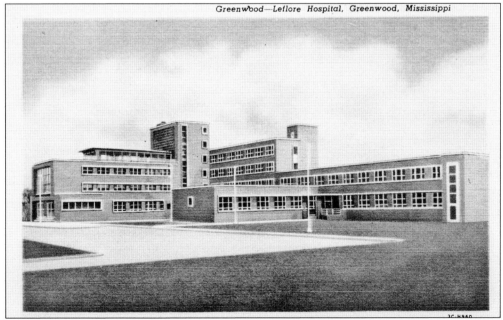

Greenwood—Leflore Hospital, Greenwood, Mississippi

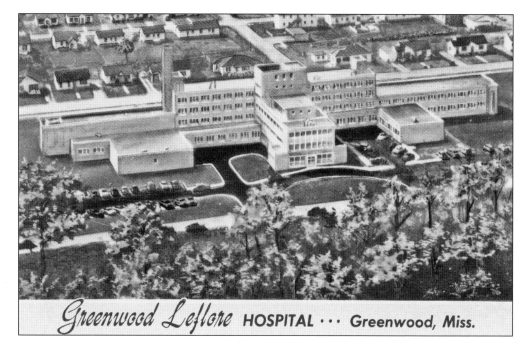

Greenwood Leflore HOSPITAL ··· Greenwood, Miss.

In April 1952, thirty-four years after its dedication, the old Greenwood Leflore Hospital (renamed in 1936) was shuttered and its patients moved one block west to the ultramodern new facility at the end of River Road. The operation had grown from a five-bed cottage hospital to a 130-bed, four-story complex. Over the years, a fifth floor was added along with new wings and updated operating and delivery suites, emergency rooms, rehabilitation centers, and other amenities, bringing the total capacity to more than 200 beds. After multiple renovations, a few features of the original hospital are still visible, including the top-floor solarium.

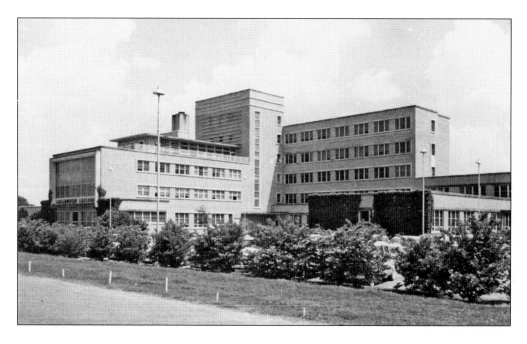

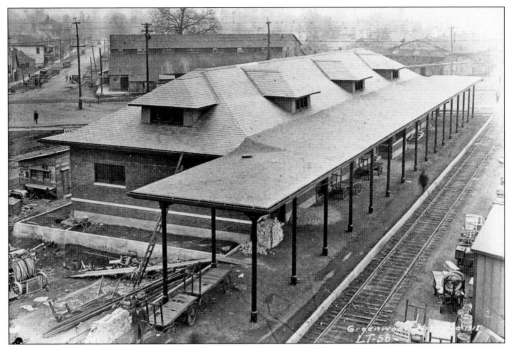

Railroads gradually made their way into the Mississippi Delta in the 1870s and 1880s. Swamps had to be drained, trees felled, levees built, and rails laid before the massive steam engines could make their way into the flatlands and lure the cotton-shipping business from riverboats. In 1888, it still took five hours to travel from Greenwood to Carrollton by coach. When the Yazoo and Mississippi Valley lines (running north-south) and the Southern lines (east-west) intersected at Greenwood, everything changed. According to the *WPA History of Greenwood*, anticipation was sky-high as the first trains approached the city: "Quite a large crowd of people were at the station to meet it. . . . Kaiser, the inimitable coon dog of Dr. Davis, gave noisy mouth as he 'treed' the big engine, whose shrill whistle scared a lot of the kids away out of town." The top photograph shows the 1917 Illinois Central depot under construction; in the background are Jucheim Wagon Works and Clarke's Grocery (the two story white building on the west side of Lamar Street, owned by Mary Charlotte Clarke's grandmother).

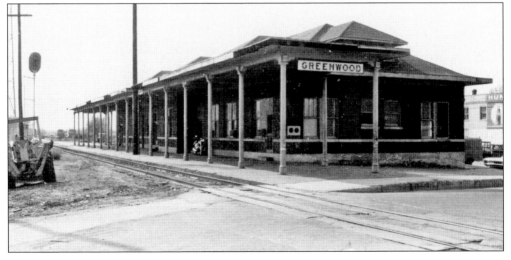

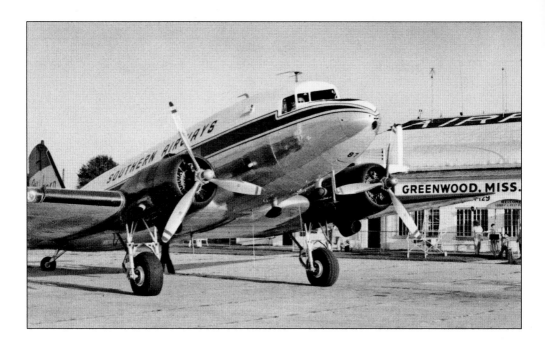

In 1928, the city purchased 160 acres of the Bell property just south of town with plans for laying down runways and establishing a true airport. Charles Lindbergh's heroics the previous year had everyone excited about commercial aviation, and the existing landing strip at the intersection of Carrollton and Humphreys Highways was going to be inadequate for future air travelers to Greenwood. A terminal and hangar were built at the airport site, and for many years, regular connections were available to Memphis on such airlines as Delta, Southernaire, and Southern Airways. In the 1970s, the long-abandoned Greenwood Army Airbase was converted into the Greenwood–Leflore County Airport. The original airport became the center of the industrial park. The airbase at one point housed thousands of servicemen and encompassed several miles of roadways. Pictured are some of the flight instructors; the man in the middle is mystery writer Mickey Spillane.

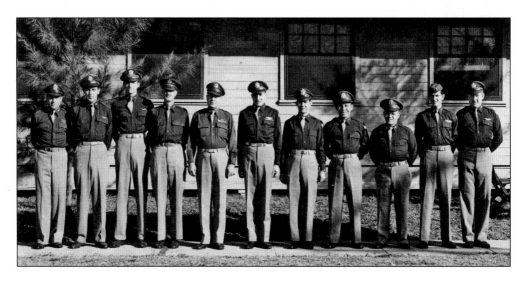

Seven

COTTON CAPITAL
OF THE WORLD

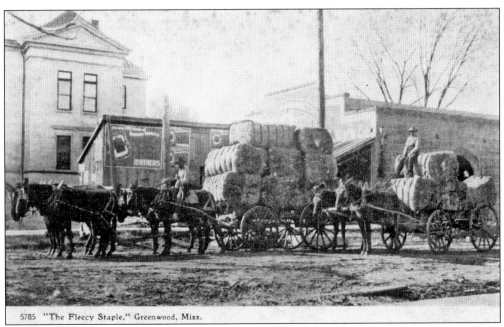

5785 "The Fleecy Staple," Greenwood, Miss.

The "fleecy staple" mentioned on this postcard is cotton. If there had not been a need for a shipping point to move cotton from field to market, it's unlikely that there would have ever been a Williams Landing or a Greenwood. This photograph dates to the period around 1906, as the courthouse is complete but the Guyton-Harrington stables on the northeast corner of that lot have not yet been torn down. The frightening possibility is that these mules and wagons may have just rumbled across the narrow iron bridge over the Yazoo.

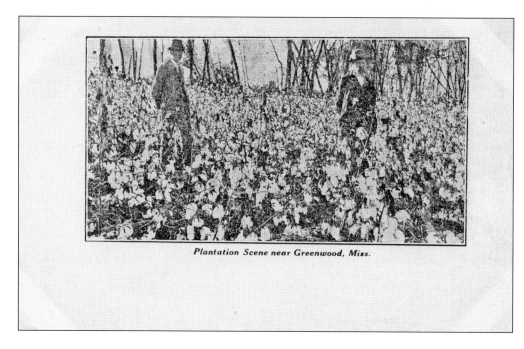

Plantation Scene near Greenwood, Miss.

Fall in the Delta has always revolved around cotton. In the years prior to the Civil War, when very little of the Delta was livable or drained for agriculture, most of the crop traveled to Greenwood from the surrounding hill country. After the levees were built and swamps drained, planters discovered that the rich dirt of the Delta was perfect for producing high-quality long staple cotton. As summer rolled to an end each year, the landscape was transformed from green and brown to a sea of white, with millions of bolls waiting to be picked. Long lines of cotton wagons were a familiar sight at local gins.

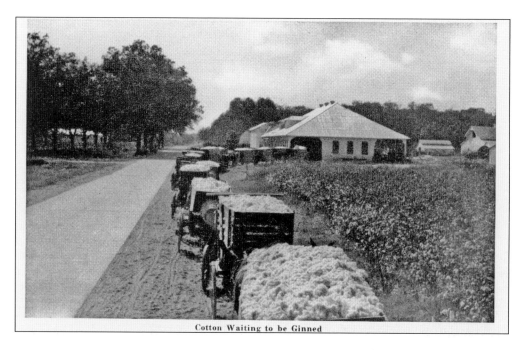

Cotton Waiting to be Ginned

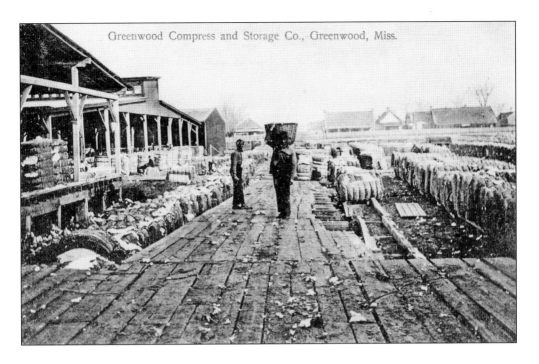

Greenwood Compress and Storage Co., Greenwood, Miss.

After the cotton was picked and ginned, the finished bales required storage until time for their shipment downriver or across the rail lines. Several sprawling compress complexes developed in and around Greenwood, each covering several acres and accommodating thousands of bales. This cotton would eventually find its way to mills and factories around the world and be transformed into clothes, sheets, towels, and dozens of other staples.

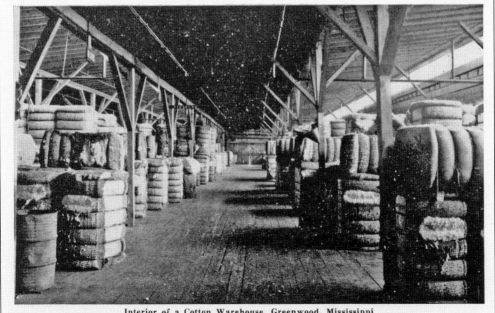

Interior of a Cotton Warehouse, Greenwood, Mississippi

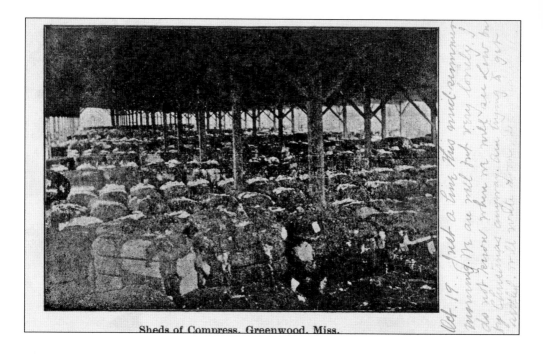

Sheds of Compress. Greenwood, Miss.

These two postcards provide some indication of the sheer number of cotton bales stored and shipped from Greenwood each year. The compresses were often no more than open sheds, and the easiest way to navigate them was to simply walk across the bales. Fire was a constant threat, as one spark could send the tightly compacted cotton rocketing across the compress, setting more and more bales on fire until a fortune went up in flames.

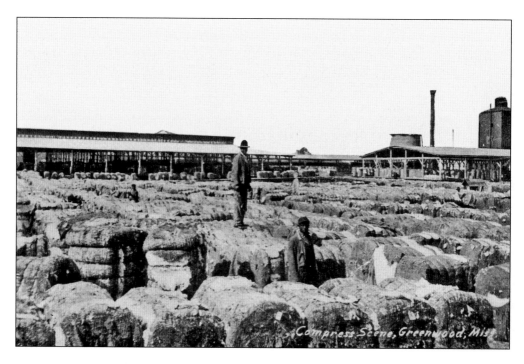

Compress Scene, Greenwood, Miss.

The cotton and agricultural economy of Greenwood depended on livestock of many sorts in the days before mechanization and internal combustion engines. Ox-drawn wagons churned up the mud and dirt of Greenwood's pre-brick streets, and mules and horses were the transportation of choice. Old city directories list numerous stables and blacksmiths, along with wagon works such as Jucheim's. Obviously, money-back guarantees were not the norm when dealing with livestock.

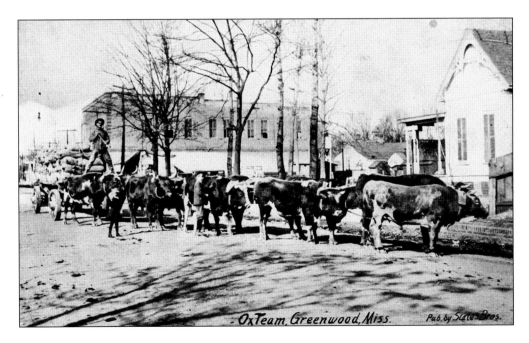

Ox Team, Greenwood, Miss. Pub. by Sales Bros.

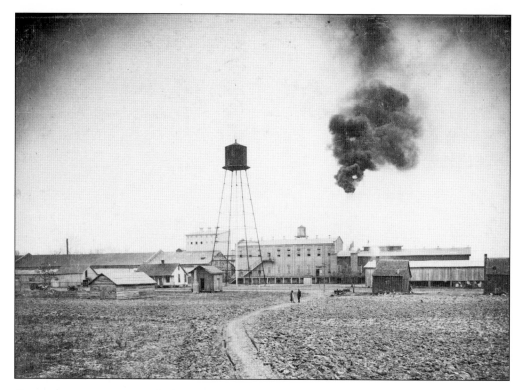

Cotton was grown primarily for its fiber, but the process of preparing it for market left some profitable remnants. The Yazoo Valley Oil Mill on River Road Extended took cotton seed and extracted oil, husks, and other valuable by-products in its complicated, smoke-belching caverns. The company was owned by Proctor and Gamble Corporation of Cincinnati, Ohio, giving it the enduring nickname "the Buckeye." The buildings seen here may still exist somewhere within the vast complex of structures still on the site. (Photograph courtesy of Sara Criss.)

Eight

ENTERTAINMENT AND SPORTS

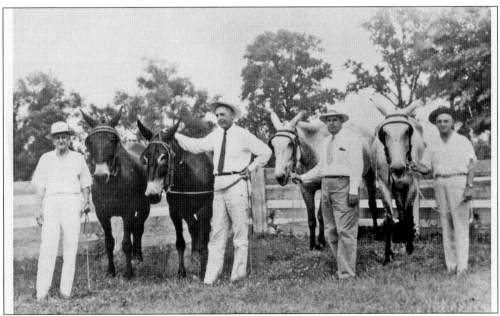

Over the years, entertainment in Greenwood has ranged from mule races to semi-professional baseball, opera to vaudeville, and fishing to golf. Pet bears were the rage in the 1850s, and at least one hardware store was topped with a roller-skating rink in the early 1900s. Circus wagons tore up the town's streets, and the Ringling Brothers subsequently helped to pay for the bricks that now line downtown. Even the Yazoo was a source of entertainment, from New Orleans showboats to latter-day speedboats and water skiing. In the days before the Cotton Ball, mule races were the primary fund-raiser for the Greenwood Junior Auxiliary. (Photograph courtesy of Sara Criss.)

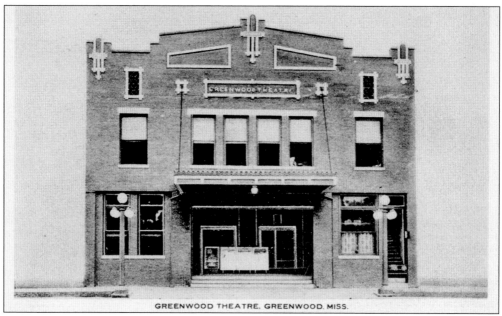

GREENWOOD THEATRE, GREENWOOD, MISS.

According to the *WPA History of Greenwood*, P. D. Montjoy and P. E. Schilling filled the lot between the 1912 Elks Lodge and Fountain's old Howard Street store with "an up-to-date $7000 moving picture show house and . . . modern combination theatre." The long-forgotten Adelaide Thurston inaugurated the Greenwood Opera House stage in January 1913 with her appearance in *The Love Affair.* Later years brought appearances ranging from cowboy star Tom Mix, accompanied by "rip-roaring riders, ropers and shooters" to "Moro, the Human Icicle." As movies replaced live spectacle and vaudeville, the theater was rechristened the Paramount. It was lost in a fire in the 1970s. Of note is the staircase on the right side of the building; this led to the balcony, the only available seating for black patrons. The Greenwood Country Club was founded in 1920 just south of the city limits.

Greenwood Country Club, Greenwood, Mississippi

From the 1890s until 1927, Greenwood's jail stood just south of the Greenwood High School site. It was demolished after the enlargement of the courthouse; the rubble was carted around Greenwood and shoveled into low spots. Grand plans were laid for a municipal swimming pool on the jail's old grounds, but the onset of the Depression halted those dreams. Finally, in 1934, ground was broken for a 200-foot-by-75-foot concrete pool, complete with bathhouse, high dives, and racing lanes. It opened during the inhospitable winter of 1935, and that next summer swimmers lined up to cool off in the new structure. The pool was filled in during the tumultuous 1960s, but the bathhouse is still standing. The lower photograph is an exercise in out-of-control civic promotion or a very confused printer, as the house is Natchez's Melrose, and Greenwood hunters wouldn't be caught dead in these outfits.

On a Mississippi Estate Greetings from Greenwood, Mississippi OB-H1334

The abundant lakes and streams in the Greenwood area provided food for early settlers. Deer, turkeys, bears, and all manner of wildlife were hunted and eaten. As the rivers were tamed and the swamps drained, the pursuit of fish and animals took on more of a sporting cachet than a matter of survival. Each year, thousands of hunters and fishermen descend on the Delta for recreation.

Riley Smith (right) and Glenn "Slats" Hardin (below) were both members of the 1930 Greenwood High School state championship football team. Smith went on to stardom at the University of Alabama and was the second player chosen in the first professional draft. He played for Boston and Washington teams. Hardin attended Louisiana State University, where he starred in track; in the 1932 Los Angeles Olympics, he won the silver medal and set a new world's record in the 400-meter hurdles. He also won a gold medal for the same event in the 1936 Berlin Olympics.

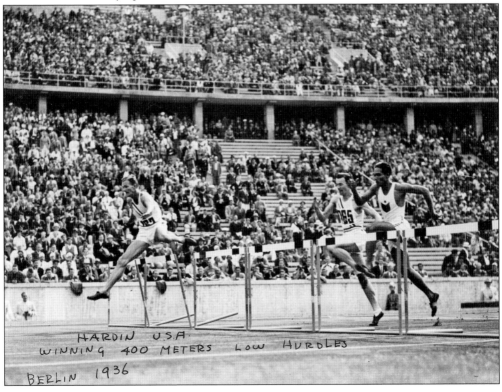

HARDIN U.S.A. WINNING 400 METERS LOW HURDLES BERLIN 1936

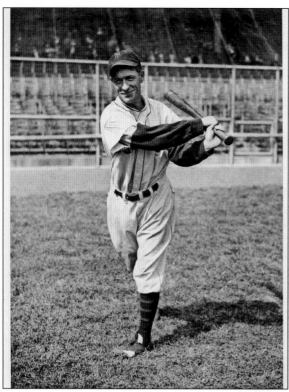

Hughie Critz (left) captained the Mississippi A&M College baseball team before playing semi-professional ball in Greenwood. After stints in Memphis and Minneapolis, he was promoted to the Cincinnati Redlegs, where he starred at second base before being traded to the New York Giants in 1930. His Park Avenue car dealership now houses Crosstown Drugs and other businesses. Dave Hoskins (below) was a native of Leflore County who played in the Negro Professional League with the Ethiopian Clowns, Homestead Grays, and Cincinnati Clowns. In 1952, he was the first black player to join the Texas League. Pitching for the 1953 Cleveland Indians, Dave posted a record of nine wins and three losses. He played for the 1954 Indians but had no wins or losses.

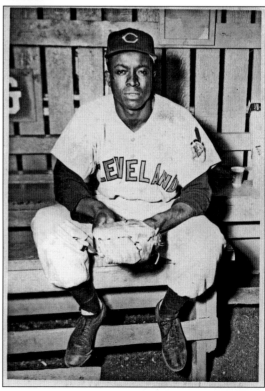

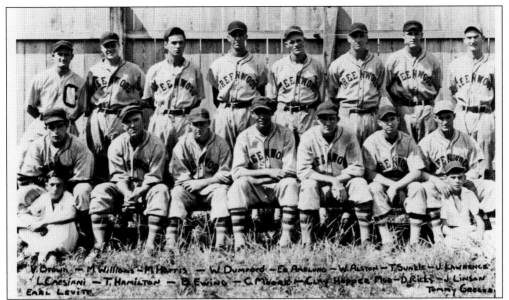

V. Brown — M. Williams — M. Harris — W. Dumford — Ed. Amelung — W. Alston — T. Sunkle — J. Lawrence
L. Cresiani — T. Hamilton — B. Ewing — C. Moore — Clay Hopper Mgr — D. Ricks — J. Linson
Earl Levite. Tommy Gregory

Clay Hopper worked in the St. Louis Cardinals's minor league chain during the 1920s and was sent to Greenwood to manage the local farm team. Among his players were Greenwood's Edwin Amelung and rookie Walter "Smoky" Alston; the batboy seated at bottom right is Tommy Gregory. Hopper later moved over to the Dodgers' organization, where he managed the Montreal Royals and a young player named Jackie Robinson. Hopper's initial reluctance to coach Robinson had vanished by season's end, when he requested that Robinson be retained in Montreal for an additional year. Robinson was instead sent up to the Brooklyn National League team, where he broke baseball's color barrier. Hopper spent many years in Greenwood after his retirement.

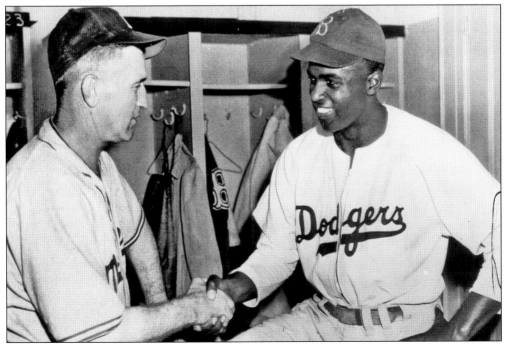

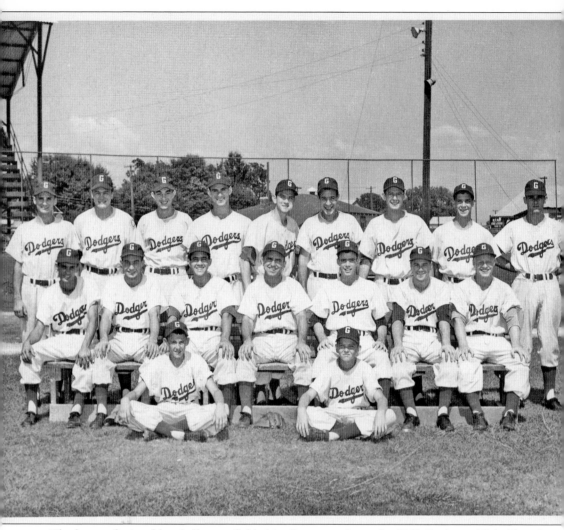

The last professional baseball team fielded in Greenwood was the 1952 Dodgers. This Class C club played its games at Legion Field, rebuilt in 1950 after fire destroyed the 1935 stadium. Of note in this photograph are Danny McDevitt (seated first row, fifth from left), who pitched and won the final Ebbets Field game in 1957, and Greenwood's own James Quinn, the batboy (seated, front right). After the departure of the Dodgers, Legion Field served numerous purposes until it was demolished for Supreme Electronics's 1960s expansion.

In the early 1950s, the Greenwood Exchange Club organized the first Little League in Greenwood. Games were played the first year on fields near the Carrollton Avenue livestock barns. A new field was completed on Henry Street in 1955, just behind the city's youth center. This 1955 photograph of the Bank of Greenwood's team includes coaches Clint Herring and F. M. Southworth and players Tommy Malouf, Sid Herring, David Fleming, Walter Pillow, Billy Tate, Tommy Inman, and Bud Keirn.

Lusia Harris-Stewart played for Amanda Elzy High School before leading Delta State University to three consecutive national women's basketball championships in the 1970s. Her 1975 U.S. Pan-American team captured the goal medal in those games, and she went on to the first women's U.S. Olympic team, where her goal was the first by a woman in Olympic history. Lusia was drafted by the New Orleans Jazz in 1977, making her the first woman tapped by an NBA team. She was part of the first class of inductees into the Women's Basketball Hall of Fame and in 1992 entered the Naismith Memorial Basketball Hall of Fame, the first female player so honored. (Courtesy of Delta State University Athletics.)

Nine

HIGH WATER

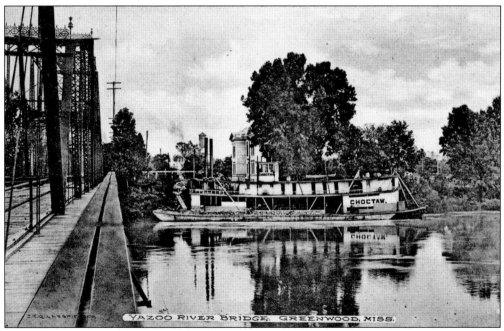

One of a succession of steamboats named *Choctaw* sits calmly at the foot of the 1899 iron bridge in this photograph. The time is after 1906, as the Leflore County Courthouse can be seen above the river, as can the roof of Davis School beyond the trees. The same scene in 1932 would have shown a river out of control, as heavy winter rains sent the Tallahatchie and the Yazoo over their banks and into the streets of Greenwood. This eastern Delta town had escaped the ravages of the 1927 Mississippi River flood, but it would struggle through 1932, 1973, and other high-water years. The rivers created Greenwood, but it should never be forgotten that they are a potent force of nature.

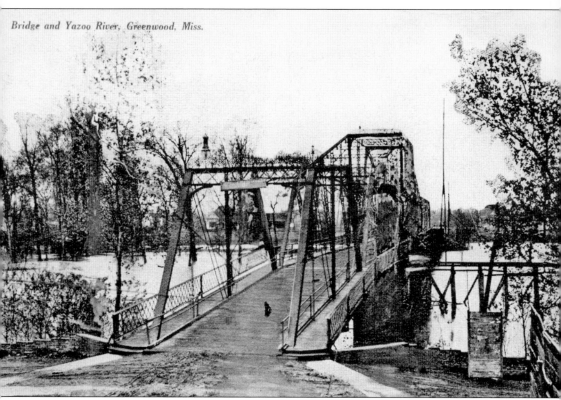

Bridge and Yazoo River, Greenwood, Miss.

The old iron bridge across the Yazoo was the only reliable connector between Greenwood and North Greenwood for a quarter of a century. While it was an improvement over Howell's ferryboat, it was still rickety, narrow, and daunting, even when the river's waters were low. In this photograph, the water appears to be high and rising. The wooden structure designed to steer debris away from the bridge's central pier is evident on the right (east) side. It appears that there is a barrier preventing access to Front Street, which may suggest that floodwaters were seeping over the banks.

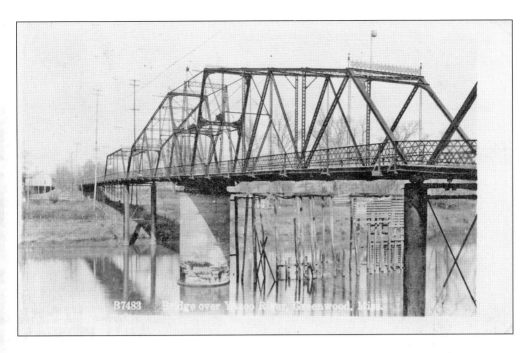

These are two views of the iron bridge in different river stages. Above, the water level is fairly low, exposing the central concrete pier of the iron bridge. This pier was the only element of the first bridge to be incorporated into Keesler Bridge. The rickety woodwork to deter debris is also clearly visible, as is a store in North Greenwood raised on stilts. The photograph below, taken from the approximate location of today's boat ramp, shows the river rising and threatening to flood.

123

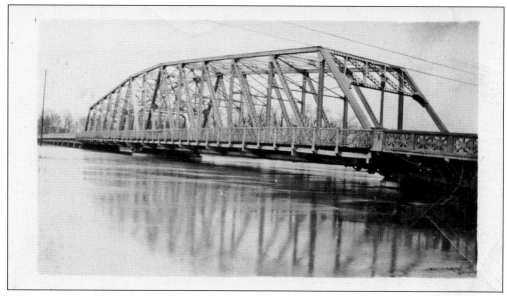

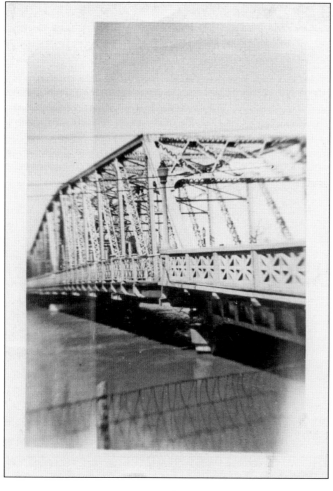

In these impressive photographs, the Keesler Bridge is new and shiny but definitely under siege by the rising Yazoo. The iron bridge was demolished (or dynamited by some accounts) in 1924, and the Keesler Bridge opened in the spring of 1925. These photographs are most likely from 1932, when the Tallahatchie jumped its banks and inundated North Greenwood. Most of its waters continued to the junction with the Yalobusha at Point Leflore and then sailed through Greenwood, passing just under the floorboards of the new bridge. Downtown Greenwood would experience some flooding during this time, but most of the damage was to North Greenwood.

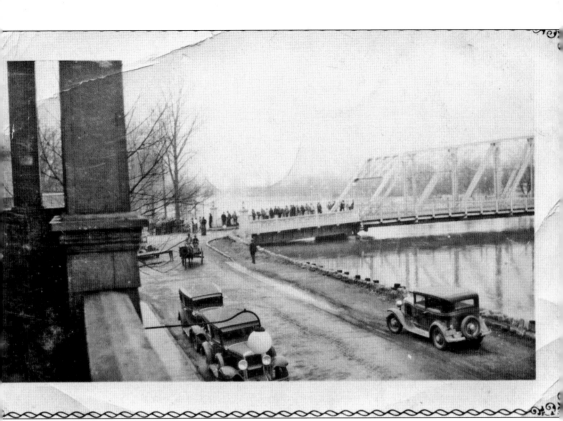

Presumably this photograph is also from 1932. The photographer is on the balcony of the Reiman Hotel, looking toward the Keesler Bridge. The water is flowing just beneath the roadway of the bridge, and something has drawn the attention of a large crowd on River Road. Notable are the presence of a horse and wagon still in use and the large trees that line River Road behind the courthouse.

Floodwaters from the Tallahatchie have submerged Grand Boulevard in this 1932 photograph taken from the intersection with West Claiborne Avenue. After it became apparent that the floodwaters would not recede for several weeks, the City of Greenwood built a raised wooden sidewalk from Claiborne to Park Avenue. Families in North Greenwood left their soggy cars at home and used boats to get around, paddling to the boardwalk and tying up their vessels so they could walk over to Greenwood. Seen here are the brick columns that once stood on the south end of the boulevard and the large house that preceded the development of the street at the northeast corner of Grand Boulevard and Claiborne Avenue.

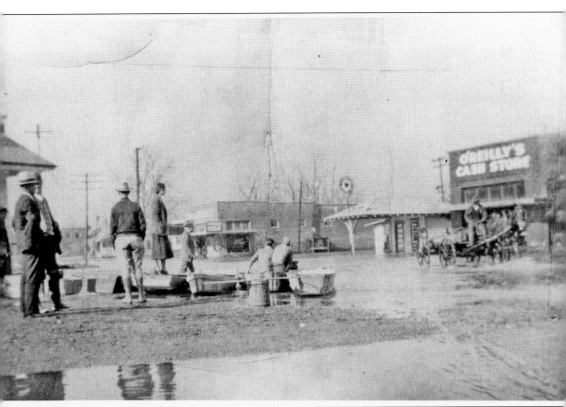

This photograph was taken at the same West Claiborne Avenue–Grand Boulevard intersection as the one on page 124. The flooding in North Greenwood was primarily from the Tallahatchie, so it had crept an entire mile by the time these pictures were made. O'Reilly's Cash Store stood on the corner that was later occupied by Fant's Sunflower; the small gas station just to its left is gone, but the next store is extant. On the far left is the "gas station" that anchored the north end of the Keesler Bridge for many years.

ACROSS AMERICA, PEOPLE ARE DISCOVERING SOMETHING WONDERFUL. *THEIR HERITAGE.*

Arcadia Publishing is the leading local history publisher in the United States. With more than 6,000 titles in print and hundreds of new titles released every year, Arcadia has extensive specialized experience chronicling the history of communities and celebrating America's hidden stories, bringing to life the people, places, and events from the past. To discover the history of other communities across the nation, please visit:

www.arcadiapublishing.com

Customized search tools allow you to find regional history books about the town where you grew up, the cities where your friends and family live, the town where your parents met, or even that retirement spot you've been dreaming about.